BEYOND PHOTOGRAPHY

BEYOND PHOTOGRAPHY

The Transformed Image

Jack Tait

FOCAL PRESS
London and New York

Type set by John Swain & Son Ltd., London
Printed and bound in Great Britain by
Morrison & Gibb Limited, Edinburgh

CONTENTS

Introduction

The photograph is the most common part of our visual language. Since the first photograph we have all been subjected to this form of communication; the process begins for a child at the same time as it learns to read. Just as a child must learn to recognise and interpret numerals, letters and colours it must learn to see a variety of grey tones as representing a person or animal. Once acquired, this photographic language becomes an indispensable part of our learning and communicating process.

Because of photography's utilitarian function there is a strong tendency to treat the photographic image in the same way as words and numbers. Words and numbers are read and absorbed rapidly and most photographs are glanced at, particularly in the case of posters, magazine illustrations and television commercials. As we are so used to the traditional photograph, the imaginative photographer who wishes to explore the more poetic aspects of photography can follow one of two paths. The first is where he produces an image of such excellence and impact that it stands apart from other traditional photographs whilst maintaining the same form. The second choice is to extend the scope of the medium, altering its form and content into something more unusual. Before pursuing this argument further it is worth examining the advantages of the traditional or common photograph. These can be summarised under three headings: Time, reality and substitution.

The traditional photographic process has the advantage of speed. The highest quality images can be produced in a very short time, and the creative process stops after the shutter has been pressed. If

the creative process is to continue after this point further time is essential.

The reason for the photograph being used commercially is that it offers an accurate and detailed representation of reality. It is wholly convincing and a product shown in a photograph commands credulity.

Lastly, many photographs are employed as a substitute for the real thing. Into this category fall most portraits, pictures of pleasing locations and pornography. The above advantages are traditional photography's strength but do not offer the same benefits when selectivity and the ability to modify the image at any point in the process become the prime considerations.

Because we live in an environment where the machine and it's products are indispensable to our way of life, photography may be regarded as the natural medium to adopt. The common photograph is the departure point and by using further mechanical processes and some selectivity and imagination, the image can be controlled and modified even past the point where its antecedents are recognisable.

The fundamental decision in making a picture comes with the choice of subject, lighting, angle of view, focus, image size, perspective and timing of the moment of exposure. Following the exposure, slight modifications may follow during development. The final stage in the process, the printing, effects further choice, ranging from the common bromide print to mural-size images on fabric or stainless steel.

This book is mainly concerned with that final stage, and how the form it takes may be influenced by the content of the photograph. This includes the use of photographs in other techniques to produce results which make the most interesting and exciting use of the photographic characteristics of both processes. Ways are suggested in which the images produced have been, and may be, applied in com-

mercial and industrial fields. Today the art scene is peopled both by image makers and image manipulators. The manipulators use the photographic image not as a substitute for reality but as the vehicle to make visual statements which are both useful and visually stimulating.

It has not been the intention here to offer to the reader ready-made solutions to visual problems, but to suggest exciting points of departure which may yield much pleasure and satisfaction in being pursued. In following these, it is probable that further discoveries will be made which may be applied to design and communication problems.

Screen

The majority of photographs which are used commercially have to be reproduced by a photomechanical process and appear as printed illustrations in newspapers, magazines and on posters. The photograph itself is simply an intermediate stage in the production of an advertisement or illustration and the object of the final printing process is to adhere as closely as possible to the original photograph, that is, to produce a facsimile reproduction. It is however, still inevitable that the method of reproduction will have an influence on the qualities and character of the final result. If optimum results are to be obtained from photography, the photographer, as well as the graphic designer, must understand the photomechanical processes and develop the judgement to know how to use their characteristics to the best advantage.

Beyond the primary objective of good reproduction there is great scope for experiment with, and exploration of, visual effects in the major processes. The whole of this first section is devoted to an investigation into the character of the photographic image when used in a graphic process.

The images are treated in as straightforward a manner as possible, discussing only those steps which are essential to the particular process. In most cases this involved printing the original negative on to either high contrast 'lith' film or a material which has an integral half-tone dot structure.

The processes dealt with are silk screen, lithography, etching and Xerography. The first three loosely correspond to the three major processes of photomechanical reproduction; silk screen and lithography are very similar to commercial techni-

ques whilst etching is a kind of hand gravure technique.

Xerography differs from the other three in that it was developed to be a superior type of office document copying system to reproduce line work only. It can attempt to reproduce continuous tone with the aid of a screen but the results are not very satisfactory. It is with the reaction of the process to a continuous tone original without screen assistance that the interest lies as it imparts its own characteristics to the photographic image.

Some of the processes described in this section are not readily available to every amateur or professional photographer. Silk screen is perhaps the easiest to carry out as both lithography and etching not only involve moderately complicated processing but also need presses on which to print the results. It would be possible for the enterprising photographer to gain access to an office rotary litho machine and to adapt an old fashioned wringer into an etching press in order to produce results similar to these illustrated. However, the main object of this part of the book is to demonstrate a little of what can be achieved by these processes and attempt to encourage those with a knowledge of photography to broaden their approach to the use of the photographic image.

Silk screen process
The chief advantage of this process is that it allows an image to be printed on to a variety of surfaces. In fact, as long as the surface is flat and fairly smooth there are no difficulties. This potential, coupled with the relative simplicity of operation makes it well suited to exploratory work with photographic images.

To start the process an image must be chosen which is of simple shape and in which the main areas break up into an even texture. The reason for this is that unless a half-tone screen is employed the picture will consist only of areas of 'black' and

Original negative *enlarged and composed on to lith film with careful shading and printing-up to preserve detail and grain texture.*

Lith film positive

Contact printing. *Lith, plus the light sensitive gelatine film in contact and the lith image printed by exposure to UV light.*

Developing. *The gelatine film on its backing is developed in warm water; the unhardened gelatine is removed leaving a hardened gelatine.*

Transfer to screen. *The gelatine is put in contact with the screen and the backing (a) is peeled away leaving a negative gelatine image on the screen mesh — the underside of the screen.*

Taping the screen. *The gap between the gelatine image and the edge of the screen frame (b) has to be taped with brown gummed paper on the inside of the frame.*

Printing *is done by means of the ink (c) being drawn across the screen by a squeegee (d). The ink rests on top of the gummed paper strips in between printings.*

Printed image *on paper cloth.*

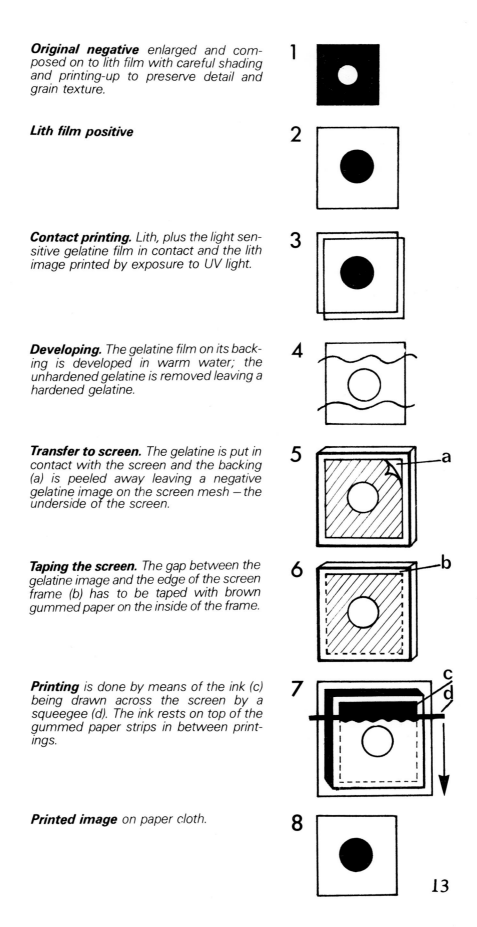

13

'white' with no intermediate gradation. The texture can be as coarse as that which appears in a rough wall or as fine as a very coarse-grained image. The object is to avoid the visual monotony of large flat areas: the texture will alleviate this fault and tends to create an illusion of gradation.

When a suitable negative is chosen it is enlarged on to a 'lith' emulsion. This can be either film, which is expensive in large sizes, or a product called translucent paper (TP)* which is much cheaper. Both materials must be handled by illumination from a red safelight and processed in a 'lith' developer (see p.134). The lith material has to be printed very carefully with highlights printed in (given extra exposure) and shadows held back (given less exposure) in order to preserve as much of the detail in the original as possible. The whole image will be either solid black or clear film but it is important to maintain as much image texture as possible.

After an image on film containing maximum detail is made, it is then contact printed on to a sensitive material which will be transferred eventually to the screen and will act as a barrier between the ink/dye and the paper. The sensitised material is a gelatine emulsion which hardens on exposure to ultra violet light. The 'solid' image areas on the film prevent the gelatine being exposed and the clear areas allow the light to penetrate and affect the gelatine. This exposed emulsion is then 'developed' in warm water and the unexposed gelatine, being unhardened and therefore still soluble, is washed off. An image is left composed of hardened gelatine which remains on the base support. At this point the gelatine image is transferred to the underside of the screen and allowed to dry, after the base has been peeled off. The screen itself consists of nylon (nylon has replaced silk or organdy in recent years as a material for screens as it is extremely durable) stretched on a strong wooden frame, and great care is taken in the stretching to

A straight single print in opaque colour on brown cartridge paper. The original negative was printed onto 'lith' film and the grain provided the tone effect — *Michael Robinson.*

14

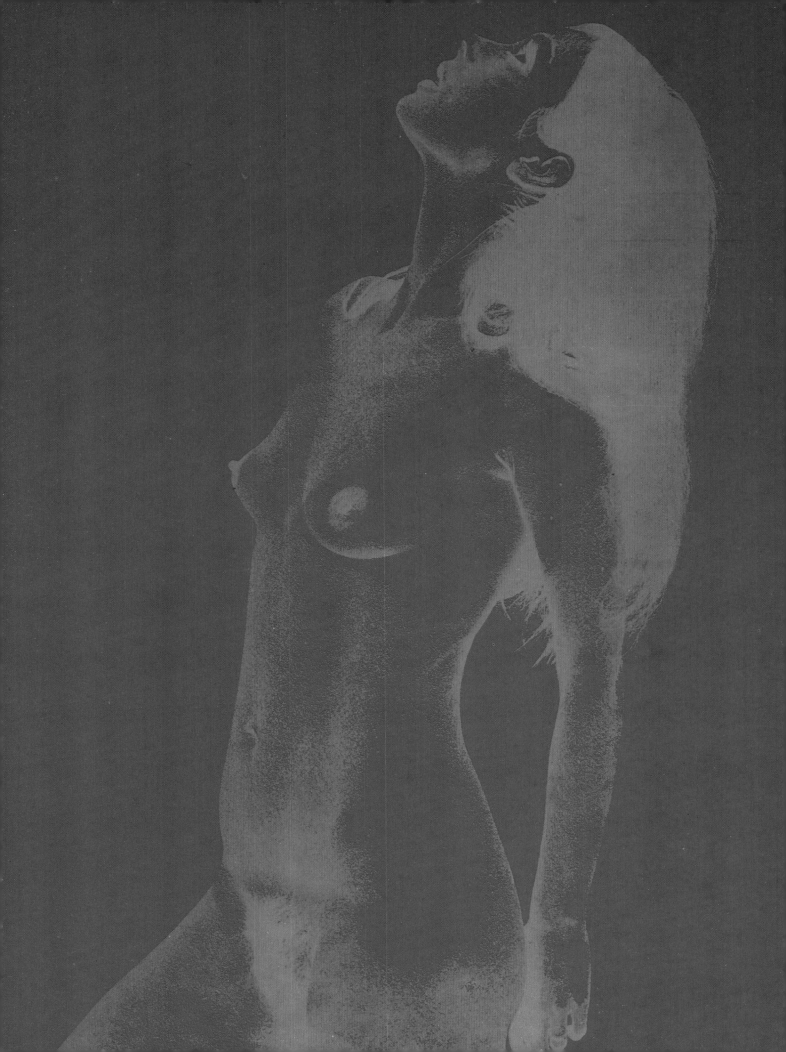

ensure that the lines of the mesh remain straight and square.

The purpose of the screen is to hold the gelatine image in place so that ink or dye can be squeegeed through the mesh on to the printing surface. Because the open areas of the gelatine image correspond to the 'black' parts of the film, (that is, the image part) the resulting picture is a positive.

Brown gummed paper strips are stuck down (on the top, non-image side) surrounding the image, which is always made substantially smaller than the screen. These provide areas where the ink may rest before being drawn across the screen by the squeegee.

The act of squeegeeing the ink through the nylon mesh has been referred to once or twice above and constitutes the most demanding part of the process. Ink is drawn across the screen from one end to the other and as the ink rolls under the flat squeegee it is forced at an angle of approximately 45° which permits ease of movement yet also creates ink pressure. The movement across the screen must be firm and very smooth as uneven speed and pressure create 'fault lines' in the image produced.

Application

It is possible to use the screen unattached to a special register table or bed and in fabric printing the screens are placed by hand and moved for each successive 'repeat'. However it is easier to use the screen when it is attached to counterbalanced arms mounted on a 'bed' when paper prints are being printed. This makes it possible to proof the screen easily on cheap newsprint and to place both register marks for the paper positioning and also, when required, print images on transparent overlay material for use in multi-colour/image prints.

The method of using a transparent overlay is briefly described below. As many pictures are printed in two or more colours some system to register one image accurately with another is essential. In the case of a two-colour print the second

screen is first proofed and then an image printed on the overlay material, which is secured along one edge to the bed. A first image print is then placed underneath the overlay and may be positioned in a particular relation to the second. Once the paper is in a satisfactory place, register marks are made on the bed so that subsequent first images will register with the second printing. It is important that the overlay be large enough and greater than the paper so that there is room to manoeuvre the first image into registration.

This process lends itself to printing an image not only on paper but on many different surfaces such as cloth, perspex, wood and metal. For the photographer, this is one of the chief attractions of screen printing, apart from the fact that it is a cheap and relatively simple method of producing numbers of large prints in one or more colours.

Colours

An effective way of using screen printing in the early stages is to employ one motif and, by successive printings in different colours, build up the final picture.

This approach has been applied to images from light-modulating machines.

Another version of this two-colour idea is where the same screen is used twice, printing in register but on the second printing masking out some of the image area. This is quite effective when the outline of the image allows easy masking with a cut or torn paper mask between the printing surface and the screen (see illustration of church detail). Whilst involved with two colour printing it is possible to produce a result from one monochrome negative in two or more colours. This is achieved by a tone separation process in which two 'lith' intermediates are made from the original by printing at different exposures so that one lith film records the shadows and the other, from the greater exposure, records the mid-tones or highlights. When screen-printing

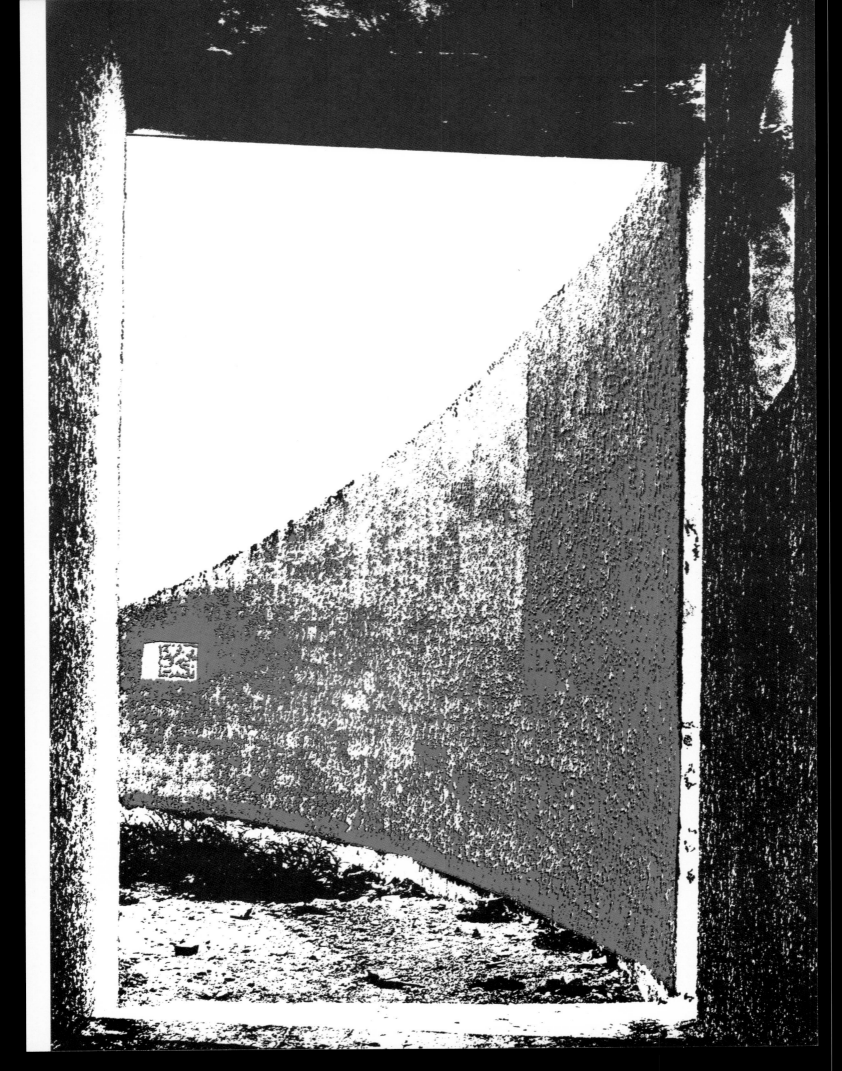

the results, the shadow screen is printed in a dark colour and the other in a lighter. Provided that the registration is good the results are convincing. This same technique may be applied with equal success in the lithography process (see page 25).

In connection with any multiple colour printing it should be remembered that, subject to the translucency of inks or dyes in use, an additional colour will be realised by one colour overprinting another. This means that a third colour is made from two colour printings.

When more colours are required it is possible to use a colour transparency as an original and produce three colour separation negatives from them (see page 138), these separations then being printed on to the lith film in the normal way. It is possible at this stage that the flat images lacking continuous tone will not be wholly satisfactory. Here the process is approaching the technical regions of facsimile reproduction and the results gained may not justify the extra difficulties.

However, it is well worth outlining the methods available for producing a continuous tone effect so that it may be used in conjunction with such 'separations' and also applied as an additional routine for simpler printing ideas. The continuous tone effect is produced by means of what is termed a half-tone screen and in the printing industry the effect is produced by applying a very expensive finely ruled screen to the image in a process camera. Fortunately for the amateur a material is available which has an integral half-tone screen and does not require the use of the special screen. A picture printed on to it is converted into a dot image where dark tones are represented by large dots and light tones by very small dots. (See illustration of half tone dot structure page 135). On page 134 the techniques of using this Kodak Autoscreen material are covered in detail.

Although the dot size will be coarse when the image is enlarged to normal screen size it can be

The original photograph was taken in Malta of a partially built church. The wall texture lent itself to the production of a tone effect via 'lith' film and silk screen printing. The second colour was produced by cleaning the screen and masking off the unwanted portion of the image with paper. This colour was over-printed in an opaque colour in as near exact register as possible — *Nicolette Tait.*

19

used imaginatively, particularly when combined with flat images or coarse grain effects.

Ideas for visual effects

During experiments with half-tone screen images it will soon be discovered that when two screens are superimposed a secondary pattern effect is generated which varies according to the relative positions and angles of the screens to each other. This is termed the moiré effect. As with most such phenomena this effect can be turned to advantage and, if deliberately induced, provides another creative tool for the designer of print images. Another possibility is to experiment with extreme degrees of enlargement of very small originals containing a screen. The pattern of a large dot structure may be used to great effect, either individually or with other images, and the screen process seems to respond very well to exploratory work (page 104). The same interest is to be derived from enlarged photographic grain which, in addition to possessing a unique character of its own, also provides a type of continuous tone result which helps to break up flat areas of colour. The quality of grain produced is highest if the required enlargement is accomplished in one step. But if several steps are used then it is best to convert the grainy original into a lith image as soon as possible as enlargement from lith images on to further lith material tends to maintain sharpness and the inherent grain of the intermediate material does not interfere with the original grain structure. The fact that the screen process lends itself to printing images on many different surfaces was mentioned above. The most common surfaces used are fabric and in recent years, plastic. In the case of fabric, the nature of the surface texture and colour of the material contributes much to the visual appeal of the final picture. It is easy to imagine the vast change in appearance of an image on coarse hessian compared with one printed on a fine chiffon. When transparent materials can be

used you may build up the final image from a base image overlaid with a top one printed on muslin, lace or chiffon. Printing images on plastic has rather more commercial outlets than creative ones as the surfaces tend to be uninteresting. Material having a substantial thickness such as glass, Perspex or other transparent plastic sheeting, and an image printed on both sides has interesting visual and three dimensional attributes. It is possible to build up a deep block of images in the form of a Scandinavian sandwich which may be viewed from many different angles. Perspex is also made both opaque and transparent colours some of which have ultra violet fluorescent properties. This material has been used by students to make successful suspended exhibits in which the image may be viewed from either side and is free enough to act as a simple mobile.

Quite a different effect is produced if a screen image is printed on polished metal and the picture has the property of appearing in negative or positive depending on the viewing angle and the nature of the colour used. Metals which suggest themselves for this treatment are aluminium, zinc, copper, brass and stainless steel. A stainless steel glazing sheet may be used if the extra 'dimension' of the reflection is thought interesting when seen in conjunction with the printed image.

A final idea which might be a rewarding avenue of exploration is to print on a wooden surface which has a distinctive wood grain pattern. If a dye were chosen which would penetrate the fibres of the wood deeply it would then be possible to sandpaper or sand blast the surface with the intention of removing more of the soft than the hard wood areas inherent in the grain structure. When a relief effect was produced on the wood it could then be reprinted in another colour so that only the raised areas were affected, thus combining the two colours in a pattern that accords with the grain structure.

Despite the potential of silk screen printing and

Pages 22-23

This picture began with a bromide print of a girl's head which was cut into small strips and reassembled with each strip of image moved slightly out of place. The collage was copied and then printed on to Agfa Contour film which has the property of recording each significant change of tone from light to dark as a line. A number of copies were made at the 'first generation' stage and these were then printed again on to Contour film. From the numerous effects produced a few were selected and enlarged to make silk screens one for each colour — *Richard Wiggins*.

photographic images indicated above, this is by no means an exhaustive list of techniques. To anyone with both photographic knowledge and a darkroom or workshop it would be quite feasible to purchase silk screen printing equipment for a relatively modest outlay and experiment with the medium. Practical advice and guidance, an essential supplement to written instructions would be forthcoming either for colleges, faculties of art or from commercial printers. Some smaller colleges and schools do in fact conduct evening courses where such help would be available.

*A Kodak Product.

Lithography

Although lithography and screen printing do in some respects generate similar results, there are certain distinctions which can be made between the image characteristics of the two media.

The chief difference between the two methods stems from the manner in which the ink is brought into contact with the paper surface. In silk screen printing of the type described earlier the ink is squeegeed through the mesh of a nylon screen. In offset lithography the ink image is picked up from the plate by an absorbent roller and transferred to the paper. The silk screen produces a thicker layer of ink and has less ability to record fine detail. Because the ink layer is substantially thinner in lithography not only can fine detail be recorded but more printings in different colours are possible. In purely practical terms the lithography process is able to turn out very large numbers of identical prints without the plate deteriorating, whereas the 'resist' used in screen printing is unlikely to last very long before mechanical damage occurs. Apart from one consideration which is dealt with below, the 'litho' process is a cheap and efficient way of producing fairly long runs of images and repeat printing is relatively easy to mechanise. Many good quality office duplicating and printing machines employ the litho process and specially prepared plates can be used by unskilled people. Silk screen is, of course, a hand process in respect of the type of work described in this book, although complicated screen printing machines are used to print wallpaper and fabric in industry. The final consideration about 'litho' referred to above concerns its actual image surface quality, which is quite differ-

ent from a screen printed image. This is difficult to demonstrate in a book because all the images are printed in it by the same process. It is recommended that the reader looks at originals both to see the difference and perhaps decide which process has the greater appeal.

Before going into detail about lithography it is essential to state the principle on which it works, namely the antipathy between grease and water. The image on a litho plate accepts a greasy ink and repels water whilst the non-image areas of the plate do the opposite: accept water and repel grease. It is with the achievement of these conditions that the description of plate making is concerned.

The starting point for the production of a photo-lithograph is the same as for screen printing and etching in that a film positive is required, either with or without a half-tone screen. The only significant difference which might be apparent at this point is that the size of the screen could be very small as the process is capable of 'holding' fine detail. Because of this ability to record fine detail extra care is needed to prevent spots or marks appearing on the film positives, as they would all show in printing. Each small defect must be retouched on the film with an opaque medium before the plate is made.

For the sake of clarity in the description of plate making which follows the 'deep etch system for positives' it has been selected as an example. There are other systems of plate making, some simpler because of preparatory work carried out by the manufacturer, but these methods would not offer such a clear demonstration of how the process works.

The outline below is rather long and complicated so for ease of understanding it has been written in list form with each separate action in a numbered paragraph.

1 Sensitising the plate

The metal used in offset photo-lithography can be

Litho from an original 6 x 6 cm transparency of a bus stop in Greenwich Village, New York. The separation set were made through the usual filters on to high speed 35 mm film using an image size of ½ inch square. The subsequent high degree of magnification made the images very grainy and it is this grain which takes the place of the conventional half-tone screen. The random quality of the grain distribution generates a unique effect—*Jack Tait*.

zinc or aluminium. In this case zinc would be chosen as more appropriate for use on a hand offset machine. The photo-sensitive coating is a mixture of gum arabic and potassium bichromate which hardens on exposure to light. The coating is carried out by means of centrifugal force, that is, the plate having first been dampened and degreased is whirled round with the coating placed in the centre. The dampness ensures that the coating is distributed evenly and the degreasing is to allow the gum to adhere to the metal. The whirling machine also has a drier incorporated. This means that the plate is fully sensitive when the coating is dry and care must be taken not to fog the coating before exposure.

2 Exposing

The emulsion side of the film is placed in direct contact with the gum sensitised plate. The light sensitive gum coating is exposed through the film image to either a carbon arc lamp or other source of ultra violet light. Exposure times are between two and eight minutes, the exact time depending on the power of the light, its distance from the plate and the thickness of the coating. This exposure is best done in a vacuum contact frame which ensures perfect, even contact of the film to the plate surface.

3 Stopping out

This step consists of retouching the exposed plate if there are areas where the coating is required but which has not hardened or where there are defects in the hardened coating. A resin resist is applied to the plate which will prevent the 'developer' action reaching the plate.

4 Developing

The term 'develop' is a misnomer in this context as no reduction of silver takes place as might be implied by the name to a photographer. The process consists of removing the gum coating which

has not hardened by the effect of light. Removal is achieved by water and zinc chloride, the gum is simply washed off. The reason for adding zinc chloride is that without it the hardened gum might absorb some water and spoil the image. After development, the non-image areas are of hardened gum and the image areas consist of bare metal.

5 Deep etching
The action of the deep etch is to have the bare metal 'bitten' by acid. This etching is only carried out to a small depth compared with the etching process proper, in spite of the title 'deep etch'. The 'deep etch' description is to differentiate this process from other litho methods where no etching takes place. The etch solution consists of hydrochloric acid, zinc chloride and water, and its purpose is to remove metal, thus lowering the final image in order to prevent mechanical abrasion during printing.

6 Clean out deep etch
Following the etching the acid solution must be cleaned off the plate and this is done by means of a water absorbing spirit solution, usually of alcohol although methylated spirit would work as well.

7 Second stop-out
At this point the plate may need further retouching to make good any defects. In that case the defects often occur in the non-image gum coating which may have been weakened during etching. The solution used this time is gum arabic which reinforces the original gum coating.

8 Metal laquering
In order to lengthen the life of the plate by making the clean metal image areas more receptive to a greasy ink it is lacquered with a spirit based lacquer made from either a vinyl or PVC resin. After this, the image is ready to be checked.

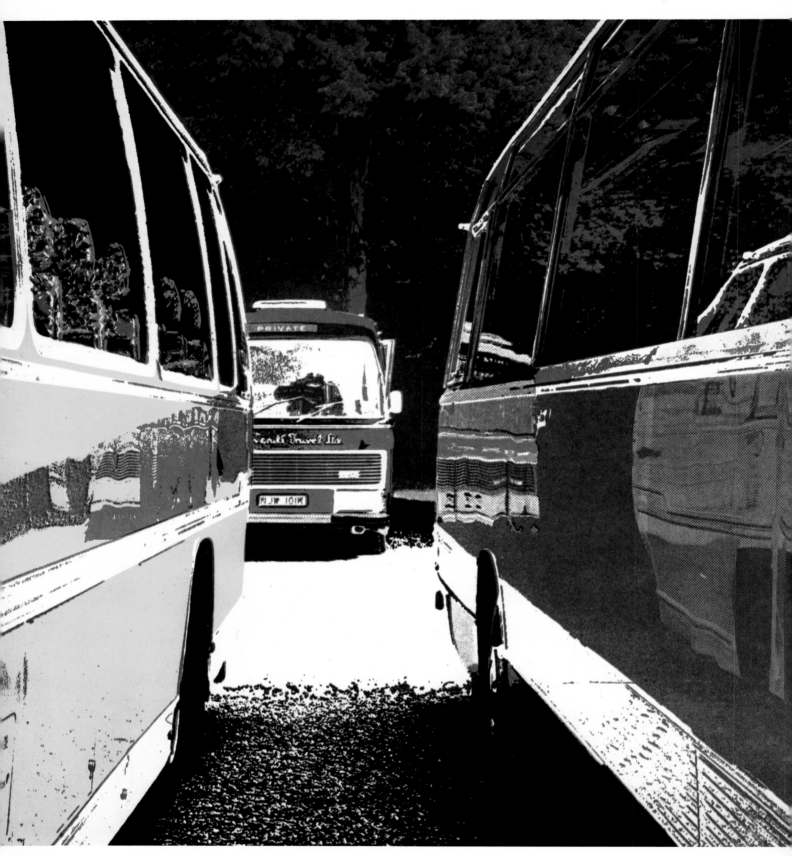

9 Ink up

The image is checked by applying printing ink to the lacquered areas: a greasy ink does not adhere to the damp-retaining gum coating and sticks only to the lacquered metal.

10 Gum removal

It would be quite feasible at this point to print from the plate but after some use a fault would develop — the hardened gum coating, originally formed by the action of light, would continue to harden and would be less and less able to retain water. As the whole process depends on the ability of the different areas of plate to retain water and grease respectively the plate would soon become useless. To prevent this problem the hardened gum is removed from the plate by a solution of weak sulphuric acid and hot water.

11 Re-coating with gum

The non-image areas have been cleaned in step 10 and must be recovered with a new gum solution. So that it does not harden on exposure no bichromate is added and the gum arabic will continue to retain water, with regular reinforcement, throughout the life of the plate. This process of reinforcement is important and a dilute acid is added to the gum to enhance the ink repellant properties of the gum coating; this is necessary because the constant application and retention of water in the gummed areas tends to dilute and diminish the coating. The process of plate making is now complete and it is ready for printing.

Printing the plate

Prior to the actual transference of ink to paper the plate must first be dampened so as to charge the gum coating with water and enable it to repel a greasy ink.

Following this the plate is then 'rolled up' with an ink-coated rubber roller — the ink adhering to

This picture was extracted from a single monochrome photograph, which was printed a number of times on 'lith' film, each colour being prepared by cutting out sections of film which had been printed in a number of varying densities. Each colour plate was made from these sections which had been assembled on clear acetate sheet in register with a master image. All the images were printed and retouched or reduced with infinite care so that the right colour was produced by overprinting. Particular attention was paid to the reproduction of convincing reflection effect — *Charles Meecham.*

Original negative printed on to lith film as in silk screen.

1

Lith film positive ready for contact printing by UV light source.

2

Zinc plate prepared and degreased in order to be able to receive the sensitive coating.

3

Zinc plate coated on whirling machine with a mixture of gum arabic and potassium dichromate.

4 (1)

Contact printing. Lith and plate brought into contact and exposed.

5 (2)

Stop out – exposed plate retouched.

6 (3)

Development – unhardened gum coating removed. (a)

7 (4)

a

Deep etching. Bare metal (b) is lightly etched. The etch is then cleaned out and the plate is retouched.

8 (5) (6) (7)

b

Metal lacquering is carried out on the plate and the image area (c) is made most receptive to ink and the plate life is lengthened.

Ink-ups. Plate inked with greasy ink which only adheres to image area.

Gum removed & recoating. In order to maintain the water retention properties of the gum it is renewed by a non light-sensitive gum coating (d).

Dampening plate and printing. Plate damped to charge gelatine with water (e) and ink applied (f).

Offset printing. Image (i) transfered to a roller (ii) and put down on paper (iii) which is registered on a heavy metal plate by clips (g).

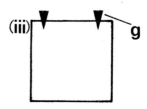

Left
This triptych of two colour lithos shows the different images brought about by varying the colour and tone of ink used. The two images which make up each colour were collages cut from bromide prints of the interior of a pub. Considerable liberties were taken with the original architecture and some faces appear a number of times at the same bar —*Mike Kay.*
Right and Pages 38 & 39
A set of lithos made from stroboscopic pictures of a figure moving in a studio against a black background —*Nicollette Tait.*

the image areas only. In offset printing a very heavy roller covered with an ink retaining blanket is passed over the plate, picking up the ink image and then transferring it to the paper (see diagram).

As was implied above, pre-sensitised plates are available which simplify the process to a few steps. There is no etching and the image 'sits' on the plate surface. After exposure this type of plate only needs developing in a proprietary solution and it is ready to print. The 'run' on this material is obviously limited when compared to deep etched plates but considerable numbers can still be made with modern pre-sensitised materials.

Whatever materials are used to make the plates it is important to attempt to get the best out of any process. It pays to exploit the ability of litho to put down a number of colours and images and to capitalise on overprints and mixtures of a half-tone dot, flat 'line' type images (images with no screen) and very grainy images. With litho's fine detail qualities photographic grain can be fully exploited and in one of the illustrations in this book a colour separation set was made from a colour transparency on to very grainy stock. On enlargement, the graininess acted as a half tone screen in that it reproduced the effect of continuous tone. The only technically difficult part was to produce grain on the film in the shadows, the mid-tones and the highlights. To achieve this the original film must be inherently grainy, it must be developed in an active print developer, used dilute to prevent too much contrast being produced, and the degree of enlargement must be high, in the order of 20x or more. The attractive effect offered by this technique is a colour change over flat areas produced by the fact that grain distribution is random, as opposed to the regular nature of a conventional half tone screen. When three random grain patterns are superimposed in the three secondary printing colours the random grain distribution prevents the colour separation from working correctly and other

colours are produced by different permutations of yellow, magenta and cyan. An example of this phenomenon would be the case of a large red flat area in a colour picture. Normally red is made up of almost equal amounts of magenta and yellow. In a half tone screen red would be produced by each yellow dot being adjacent to a magenta one over the whole red area. If grain is substituted for a regular half tone screen then sometimes a yellow dot will lie adjacent to a magenta one and make red. Sometimes the yellow dot will lie on top of the magenta dot making a darker red one, at other times a preponderance of yellow ots, or magenta dots will give rise to yellow or magenta areas. So there are at least four possible colours produced instead of one only.

Scope in application

The permutations of half-tone grain and flat images are endless in just the same way as the choice of colour combination. Hitherto little use has been made of this potential in the advertising business or the printing industry, the preferences being to keep to either drawn images or straight facsimile photo-mechanical reproduction. In the past there has perhaps been a tendency for the technical difficulties inherent in a communication process to govern and limit the adventurous application of the images. This seems to run contrary to the drift towards newer methods of image communication and manipulation like colour television and colour synthesis. The photographic image now occupies such a prominent position in communications that it is no longer defensible to confine attention to the straight uses of a medium. The attitude expressed above would seem to point to a fine art approach to the subject rather than a design-based one and not to be strictly relevant to the problem of communications. However, the author believes that an artificial rift exists between the fine art and design areas and that this has been widened by unimaginative people

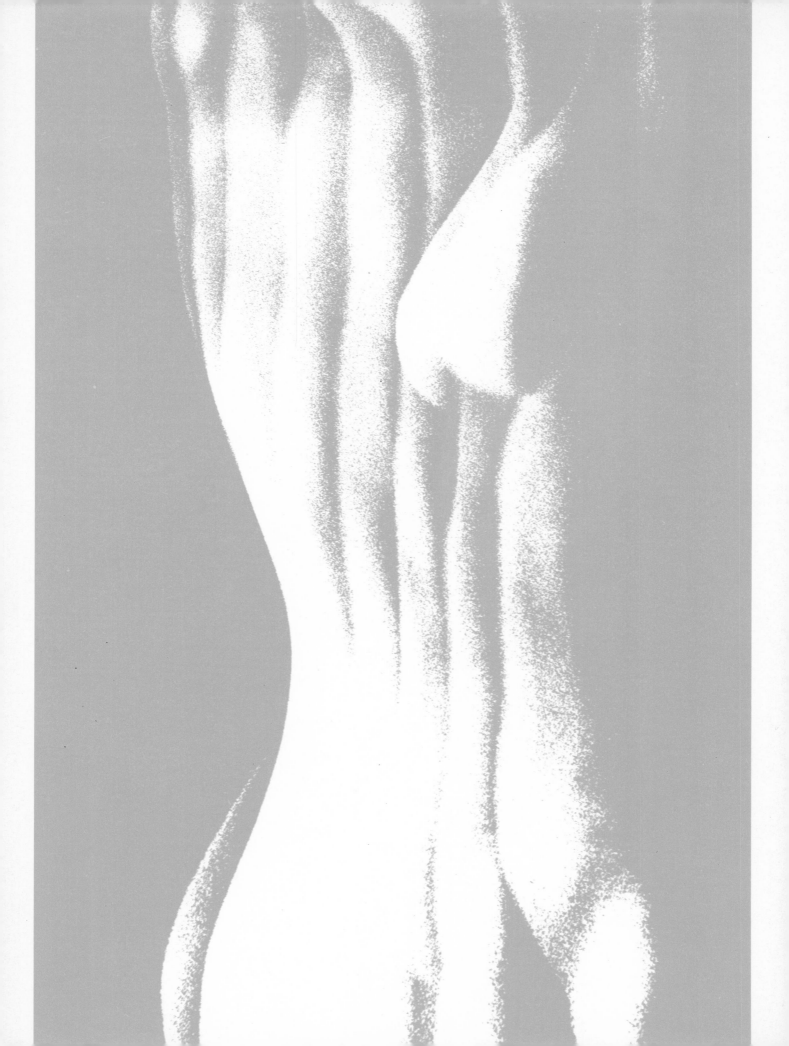

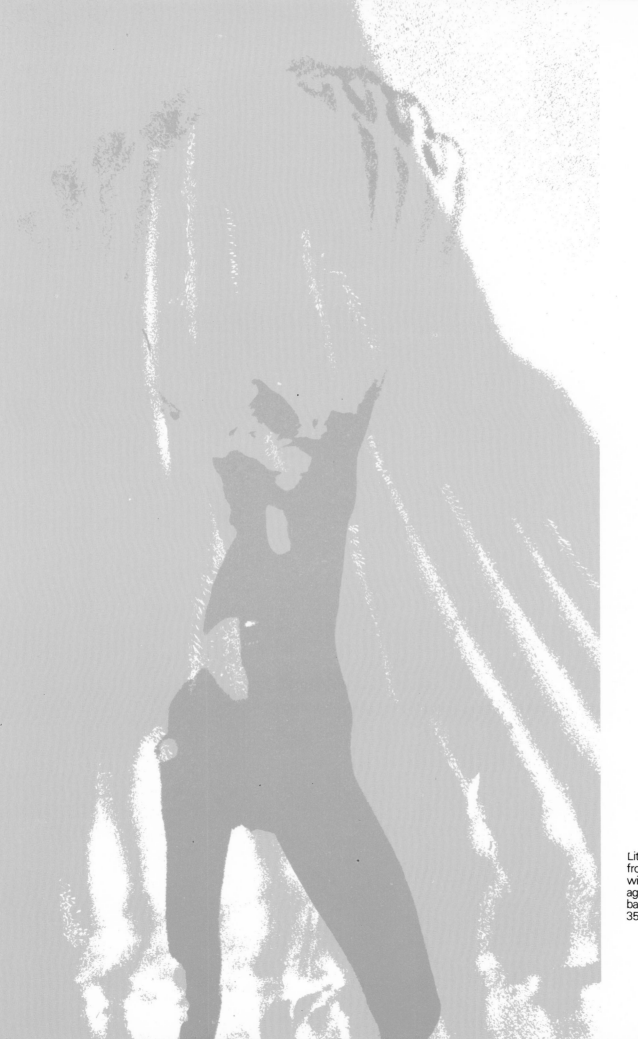

Lithographic prints made from a picture series taken with stroboscopic lighting against a black background, as on page 35.

from both fields. The function of fine art activity is to investigate and explore all ways of producing images and to act, in effect, as a visual research area. It would seem natural that the results of effective research should be immediately applied to design and communication problems and that no demarcation between the research and application should be apparent.

In many centres of visual research and application the increasing use of photography, including film making, is helping to break down the barriers between previously rather narrow views of creative activity and, where there are groups of imaginative and open minded people, it is likely that the unfortunate distinctions between art, design and photography will eventually wither away.

Etching

Of the graphic processes discussed here etching is the one which contributes most to altering the original character of the photograph, yet it also adds its own exciting qualities. Moreover, it is a process which permits hand control at the etching, 'inking up' and the 'wiping out' stages. The end results can be altered drastically according to the skill and judgement employed at these points. A further factor which has a profound influence on the results is that for each print off the plate, separate inking up is necessary. This tends to make each 'pull' bear individual characteristics.

In order to understand the creative potential of the process it is essential to be familiar with each step in handling it.

As is the case in most graphic fields the original photographic continuous tone negative is printed on 'lith' film, with or without a half-tone screen according to the image requirements. It can not be stressed too much that infinite care should be taken at this stage to ensure the best quality results, and the processed 'lith' film may be worked on with a ferricyanide reducer and retouched with blocking-out fluid to bring it to the highest standard.

The object is always to preserve maximum detail throughout as the material is designed to turn the picture into areas of black and white only. The parts of a continuous tone negative which become black are only controlled by the amount of light which the film receives, so that if the best results are sought the exposure is extremely critical.

This 'lith' film image, a positive, is contact printed

Pages 42-3
An infra red monochrome film was used to produce a picture of Hadrian's Wall at Cuddy's Crag, Northumberland. This film has the ability to penetrate haze and to show distant detail in addition to causing blue sky to record black and greenery to record white. The grainy nature of the emulsion helped to preserve tone whilst the black areas of the rocks 'wiped out' during inking up. Sufficient grain texture was preserved in the sky areas to retain ink and so print almost solid colour. The balance between rough and smooth shadow portions of the image is well demonstrated in this picture and is the special characteristic of this process which justifies its use. Zinc etching — *Jack Tait.*

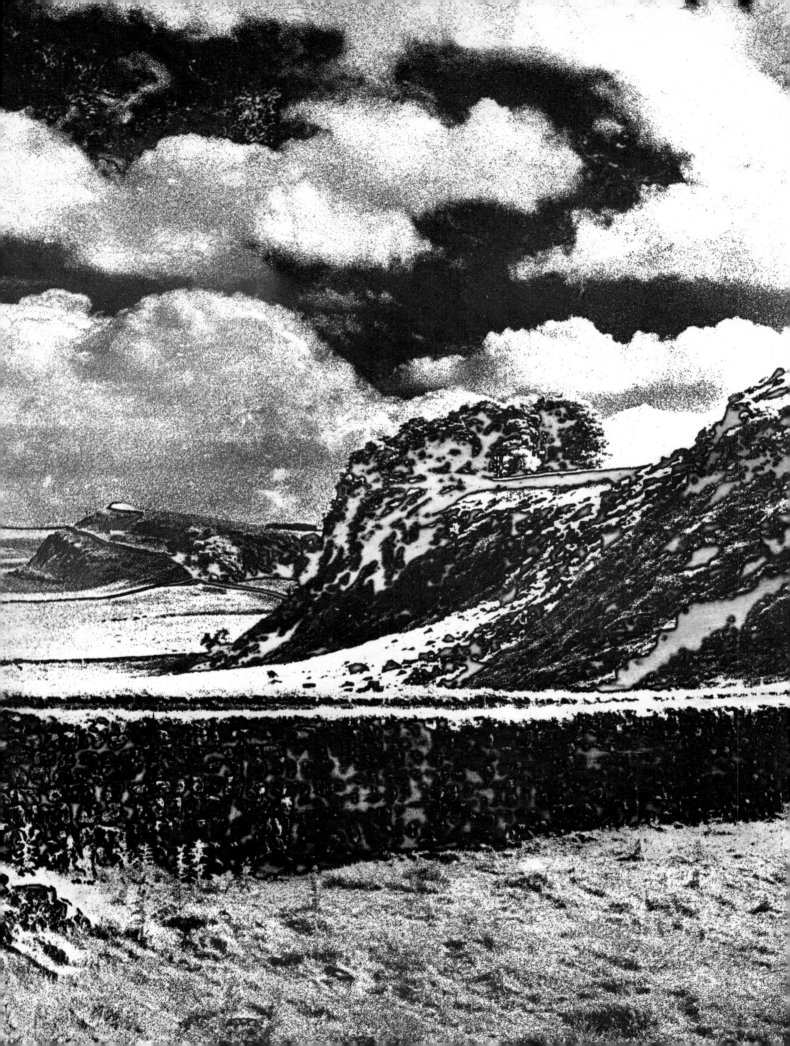

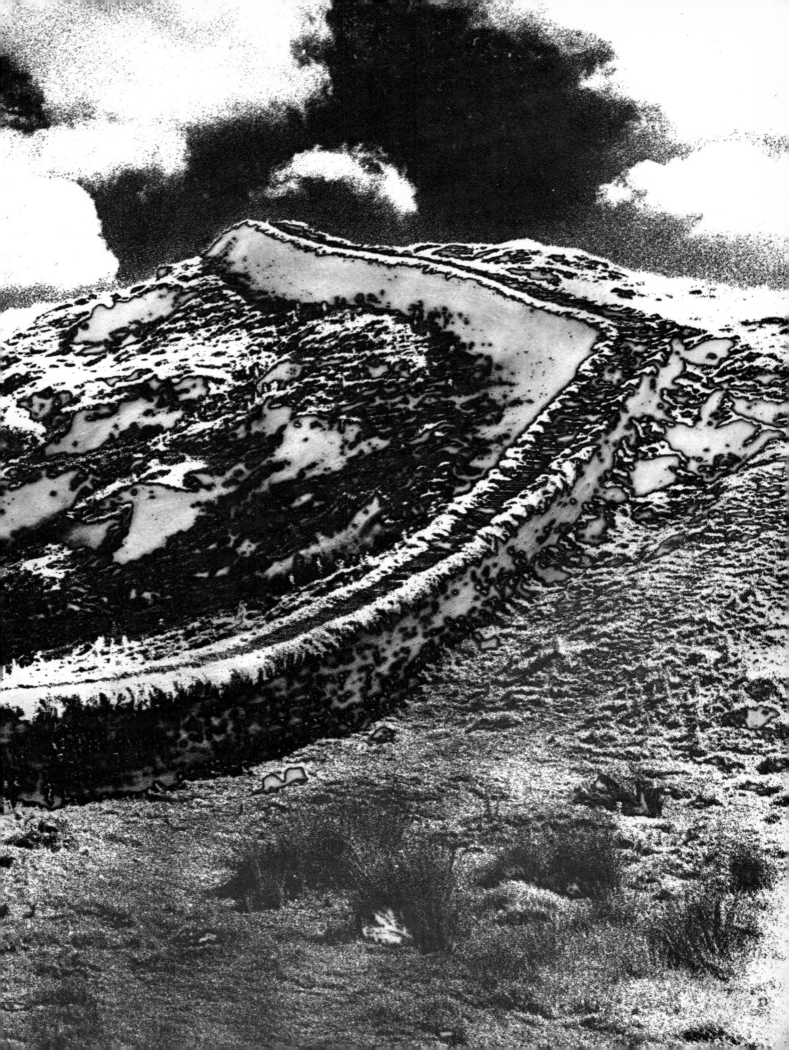

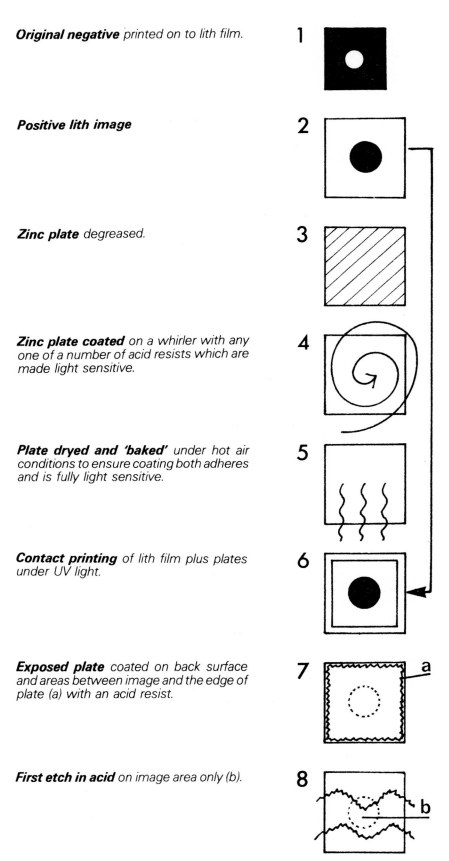

Original negative printed on to lith film.

1

Positive lith image

2

Zinc plate degreased.

3

Zinc plate coated on a whirler with any one of a number of acid resists which are made light sensitive.

4

Plate dried and 'baked' under hot air conditions to ensure coating both adheres and is fully light sensitive.

5

Contact printing of lith film plus plates under UV light.

6

Exposed plate coated on back surface and areas between image and the edge of plate (a) with an acid resist.

7

a

First etch in acid on image area only (b).

8

b

Aquatinting. If aquatinting is required the plate is dusted with fine resist powder in a special dust chamber. The resin settles on all areas of the plate.

Heating — the plate is heated and the resin fused on to the metal providing a textured resist on the image areas.

Second etch. This texture is lightly etched and the process of dusting, heating and etching may be repeated any number of times with different areas being selected or stopped out.

Inking plate. The stiff ink is rubbed into the image areas.

Removal of ink surface is done with cloth and then paper to ensure that highlights (a) are clean and print white.

Printing. Dampened paper is put over the plate and pressed into contact by the weight of the press roller.

*Steps 9-11 may be bypassed if no extra texture is needed.

on to the metal plate. The metal used may be zinc, copper or steel and each one has it's own characteristics. The description which follows applies only to the use of zinc. The special treatment demanded by copper and steel will be dealt with later on. Before contact printing can take place the 'plate' has to be prepared as follows: The surfaces must be polished and be absolutely free from any trace of grease. This degreasing may be carried out by means of a mild pumice abrasive or a detergent washing powder and the plate rinsed afterwards. It is very important not to touch the plate surface at this point as fingers will put grease marks on the plate.

To etch the plate selectively resist must be present on the surface, sides, and underside of the metal so the degreased plate is now coated with a light sensitive resist. This has to be carried out in such a way that the coating is very thin and absolutely even. In the printing industry this is done by a machine called a whirler which spins a quantity of resist placed in the centre of the plate out to the edges. The centrifugal force created ensures a thin and even coat and as the whirler incorporates a heater the coating is dried at the same time. The sensitivity of the coating is mainly in the ultra violet regions but it is handled by weak artificial light to avoid fogging the plate. Some resists are so sensitive that they must be handled only by red safelight. When the resist coating is perfectly dry the contact printing is carried out. The exposure is made by placing the two components in a vacuum frame to ensure absolute contact. The light source for this exposure is usually fluorescent tubes which emit a substantial quantity of ultra violet besides visible light. An older light source still in use is the carbon arc which is very rich in ultra violet radiation. After approximately three to five minutes exposure the ultra violet light has hardened the exposed areas of the resist and the plate may be 'developed'. This development is effected by means of a solvent

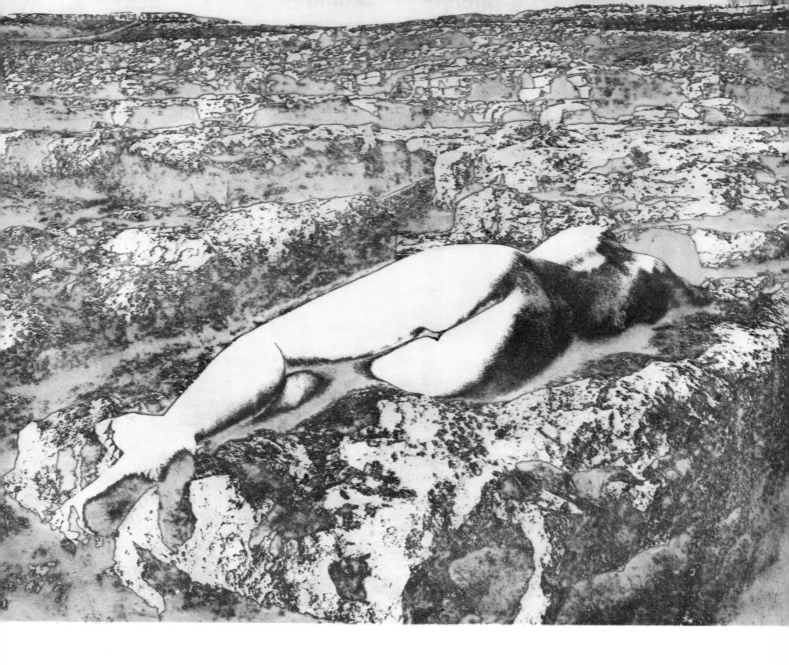

The photograph of the
nude on the rocky shore
was first printed on to
Agfa Contour film which
produced the very fine
linear qualities, and
because the detail was so
fine the film was put down
on to a copper plate in
order to retain as much of
the image quality as
possible. Copper etching
—*Richard Wiggins.*

which removes the unexposed soft areas of the resist leaving an image of the exposed areas adhering to the plate. When the resist in the exposed areas is dry (with some resists the image is baked for a few minutes to harden it further) it is capable of resisting etching acid.

Before etching can commence the remainder of the plate (i.e. the borders and underside) is coated with an acid resisting coating and after this has been allowed to dry the acid etching takes place to remove some metal from the unexposed areas. The plate is immersed in a dilute solution of nitric acid and the etching of the metal becomes apparent as small bubbles of gas are formed on the surface. These are wiped off with a feather and the etch is kept in motion bringing fresh acid to the plate surface. After a few minutes etch the plate is removed from the acid, washed and inspected to find out how deep the acid has etched. This procedure is repeated until the plate is etched deep enough to hold ink in all areas but not so deep as to 'undercut' the areas coated with resist, destroying the fine detail. Because the acid works in all areas of exposed metal and not just down into the base, there is a danger of fine detail being etched away as small parts of metal separate from the plate. Following etching, the plate is washed and dried, and then the coating on the back is removed with white spirit. The edges of the plate are then filed at a 45° angle to prevent them cutting the blanket on the press. The plate is now ready for inking up. This is done using a grease base ink and it is put on the plate surfaces with a rough fluff free cloth. If the ink is a black (black ink is very stiff) this is done with the plate heated over a hotplate, as this makes the ink spread more easily. Inking has to be done very thoroughly as it must penetrate into all the fine crevices of the plate. When the plate is inked and cool the surplus ink is wiped off with the same type of cloth. This action takes times and as the ink is gradually removed the cloth is changed for news-

48

print and the wiping continued. Finally the last wiping is done with fine tissue paper to remove all traces of ink from the highlights: this is the most critical part of etching and requires considerable skill to remove ink from the light areas which have not been etched and at the same time to leave the ink in the shadows which have been attacked by the acid. During this stage more than one colour can be introduced if desired but it is not advisable to attempt this at first.

Whilst the inking process proceeds, the paper on which the print is to be pulled is soaked in water for upwards of an hour, drained and left in a damp condition. It is essential that the paper be damp so that it can be pressed into the plate to 'pull out' all the ink from the recessed areas. When the plate is ready for printing it is laid on the machine bed with newsprint underneath and the damp paper is carefully laid on top of it. It is very easy both to tear the damp paper and to smudge it so great care is needed at this point. A strong felt blanket is placed over the top of the printing paper to even out the pressure. Printing is done by passing the paper and plate on a heavy steel bed under a roller. The extreme pressure from the roller forces the damp paper into contact with the plate so that the ink penetrates it. The print has to be gently removed from the plate, stretched on a drawing board and held down with brown adhesive paper and left to dry naturally. If the print were not stretched, the paper surface would cockle and spoil the appearance of the image.

The above procedure is a simple outline of the etching process and, provided that the image suits this basic technique, an interesting image will result. The main distinguishing characteristic of an etching made with a photographic image is the effect in large areas of dark tone. Instead of printing as a solid dark colour, as they would in both the screen process and lithography, they are rendered as a pale grey. Whilst this is an attractive feature and may be used as a deliberate element in a design it is

not always wanted. The reason for the phenomenon is that the acid at the etching stage bites a dark shadow area deep and uniformly. This depth will naturally attract ink during inking but because of the relatively large area involved and the smoothness of the metal at this point the same ink tends to be wiped out. This means that the greatest concentration of ink remains in the closest textures where it can not be wiped out. In large areas having no texture except for the surface roughness of the metal itself little ink is held and the area prints light. Fortunately, this problem can be solved by creating an artificial texture in these large areas sufficient to hold ink and the dark tone thus produced can be controlled in two ways. This technique is referred to as aquatinting and is carried out as described below.

After the first etching stage and before the back coating is cleaned off, the dried plate is placed face up in a closed box. Inside this box the air is saturated with fine resin dust in suspension and it gradually settles on all areas of the plate. The period of time for which the plate remains inside the dusting box will affect the final result. On completion of dusting the plate is very carefully put on a rack and the underside heated by means of a gas flame until the resin melts and fuses on the plate surface. When cool, this resin, now in the form of a fine texture acts as a resist when the plate is reimmersed in the acid. The time of etching is governed by the depth required and this is the second factor to affect the resulting tone produced in the shadow areas. At this point the plate is often proofed and if the appearance of the print is not quite right the aquatinting is repeated until it is judged to be satisfactory. A further application of aquatinting is to create a range of tone areas by applying resist by hand at each stage and causing the plate to be etched to varying depths and textures. This is more applicable to drawn images but can be applied to suitable photographs.

This etching was made from a plain lith image which had a fine grain structure and in which no half-tone screen was used. It is, in fact, the most simple and direct method. The plate was quite deeply etched and the shadow areas deliberately wiped out to a pale grey. In the second print, colour was blended in by hand at the inking-up stage. Zinc etching—*Jack Tait*.

50

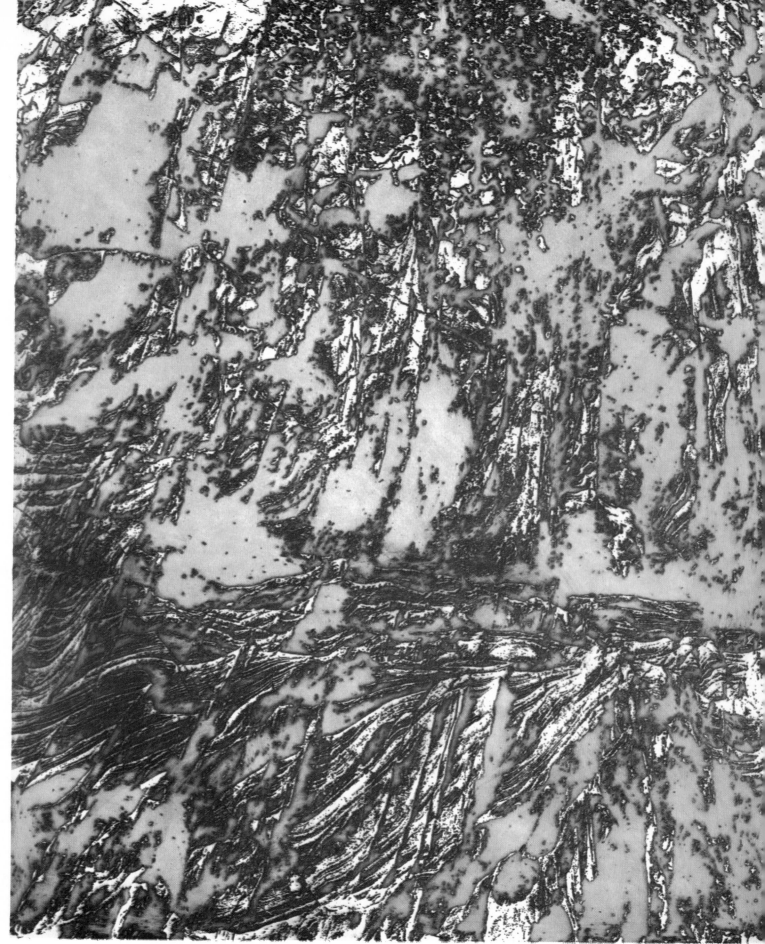

Two identical lith images were partially overlaid emulsion to emulsion to form a symmetrical shape. The original picture was of a rock texture not unlike that used in the other etching in this chapter. Zinc etching — *Jack Tait*.

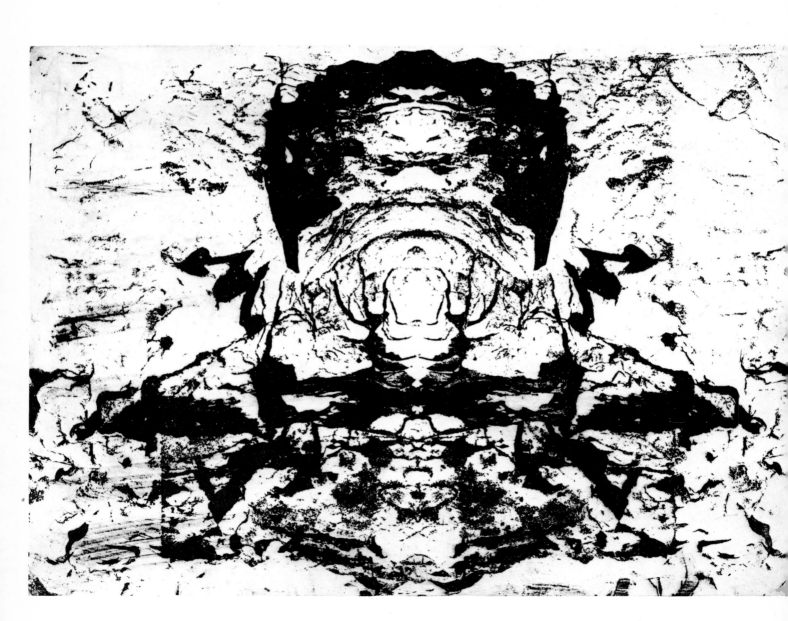

Copper and steel plates

Besides zinc, two other metals are suitable for this process. The technique of working with these metals is similar to zinc except that different etch baths are sometimes used.

Copper, whilst being much more expensive than zinc has the ability because of its close knit surface texture to retain the finest hair line detail and it is often difficult to achieve high enough resolution in the photographic film under conventional working conditions to justify the use of copper.

Steel has a most interesting property in that it offers a similar tonal effect to aquatinting without the need to aquatint. This is due to the character of the metal when etched, as the surface becomes sufficiently open and roughened to be able to retain ink.

The etch baths used for copper and steel are:
Steel: the etch may be either ferric chloride or nitric acid at a dilution of approximately 1:4.
Copper: hydrochloric acid may be used in a diluted form, alternatives depending on the depth of etch required are ferric chloride or even nitric acid.

The choice of image for etching has to be made with care and until some experience has been gained it is not easy to appreciate the extent of the changes which take place in the transition from the photograph to the etching.

It is not essential to use the etching process to produce prints: the technique may be employed to produce decorative images on metal which can either be left as they are or the etched portion filled with paint. The paint filling used can be cellulose and this should be sprayed or painted over the whole plate before the resist is removed. After the paint has dried the resist is loosened and the colour paint image remains in the etched metal. The remaining areas of metal may then be polished and the whole picture area coated with a varnish to prevent tarnishing. Once the technique of putting a resist coating on a surface has been learnt it lends

Page 54

In this pair of etchings of a white horse in the stables, one is shown without aquatinting and one with. The plate without this effect shows the nature of the steel plate which offers more tonality than zinc, and in the second example the aquatinting is rather crude and should have been carried out with more delicacy. The technique of fine aquatinting is capable of infinitely better results than the one shown but demands a high degree of skill not yet possessed by the author. It is also a more useful method of obtaining a variety of tones when using zinc or copper. Steel etching — *Jack Tait.*

53

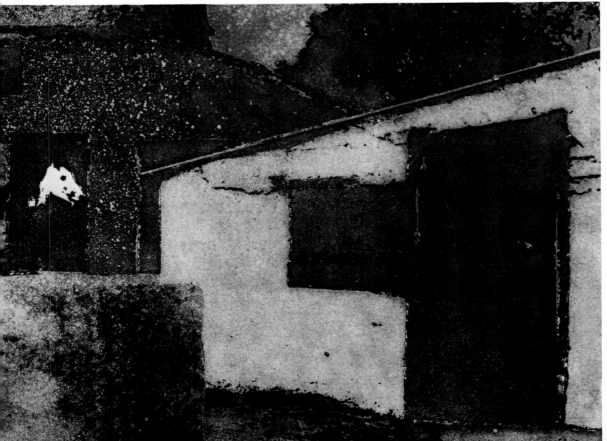

Right

A very simple seascape with a pebble foreground where an attempt was made to add a circle of texture on to the pebbles by overlaying a second identical image. The etching was aquatinted except for the breaker area which was stopped out before immersion in the acid, thus preserving a white highlight. Further work on this plate which would improve it would be to rub down the plate surface in order to reduce the effect of the aquatinting which, as in the one above, is felt to be too heavy. All types of plate lend themselves to this form of after work which offers very fine control once sufficient skill has been acquired. Steel etching —*Jack Tait.*

itself to many more image making applications where the resist may be left on the surface or removed as required. A coating which resists acid will also prevent dye or paint from penetrating any surface. The most elementary form of resist for the above purpose is one formed from very pure gelatine and potassium bichromate. This solution hardens on exposure to ultra violet light and the unhardened parts simply wash off in cold water. It will not, of course, resist acid but is effective for relatively crude work with paint and dye. For example on a wood surface an oil bound paint would penetrate the fibres and wipe off the gelatine provided that the wiping off was done immediately. Wood dyes could also be used in this way but would tend to spread laterally through the material unless minimal quantities were applied.

In this chapter the author has attempted to outline the application of a photosensitive resist to the etching process and for use in more simple image making ways. The purpose is partly to demonstrate some of the images which may be generated and partly to stimulate those interested in the use of photographic images to continue exploratory work in a field where relatively little has been accomplished.

The light sensitive resist which has been used by the author is called Kodak metal etch resist. There are also a number of instruction books on photosensitive resists published by Kodak Limited which are very useful.

Image Modification

In addition to the graphic processes as so far described there are a number of ways of modifying the photographic image which in similar ways to those processes will extend the range of image qualities available from the initial photograph. The essential difference between the methods outlined below and the graphic images is that they are all completely photographic in their means of production. Although some of the means are now little used they are modifications of materials intended for other photographic or photomechanical purposes. In every case described, the full tonal character of the photographic image may be preserved and no intermediate steps or contrivances such as the half tone screen are needed.

In the case of the toning and colour coupling methods to be described shortly the black silver image is converted to a coloured one either partially or totally by chemical means, and there is some scope for local hand control if it is felt to be appropriate. The bromoil process, described on page 73 probably offers the greatest scope for hand control of all the processes covered in this book, and it is similar in its way of working to lithography in that it relies on the antipathy of grease and water. The dye transfer process on the other hand, is primarily a method of producing colour prints by direct separation or from colour negatives. However it will not be treated in this way as we are concerned here only with the ability of the dye transfer process to place a high quality dye image on to almost any conventional photographic print.

The attractive character of stripping film (page 91) is that it allows an image to be transferred from

one base support to another and also offers the photographer the facility to distort the image by mechanical means using the result either as a finished picture or as an intermediate step in any other process.

Two other methods of image modification employ multiple or varied images in one picture. As a process, photography is perhaps the one in which it is easiest to make a picture of a number of images on one piece of paper. By multiple printing any number of images can be used, and because of the optical means employed to repeat the images there is much scope for experiment: the results are quite different from any other means of putting down a multiple image picture.

Quite different results again are available by using a technique known as collage, where the picture is built up mechanically by the individual units being pasted together on a support. By using parts of photographs in this way most unusual pictures can be made which derive their impact from the fact that most photographic images are accurate representations of real things and collage allows any two or more incongruous objects to be juxtaposed. Obviously, similar effects are obtainable by multiple printing but accurate register work is more difficult.

A further reason for including a description of multiple printing and collage is that with these techniques it is possible to combine and permutate many of the images produced by methods described elsewhere in the book. As the reader will imagine, the number of possible combinations of these methods is very high and the illustrations which appear in this book are but a very small proportion of those available. It is important at first to become familiar with each method or process in order to recognise its individual character and it is very helpful if you have some idea of the particular visual effect you are seeking. Because of the relative cheapness of the processes outlined in the follow-

ing four chapters, it is both simple and desirable to begin the tests on these techniques by using the same photograph in a number of different ways in order to make the individual characteristics discernible.

Toning

In the production of an ordinary bromide print the paper is coated during manufacture with an emulsion of gelatine and light sensitive silver salts. The silver salts in their unexposed state are referred to as silver halides and may be halides of bromide, chloride or iodide in a particular combination which in the case of projection paper has a preponderence of silver bromide. Following exposure under the enlarger the print is developed, whereupon the exposed halides are converted into black metallic silver. The task of the fixer is to render the unexposed halides soluble when they may be dissolved out along with the hypo during the final wash.

In preparing for toning the first step is to bleach the print in a solution designed to reconvert the black silver into a light sensitive halide, which can then be reformed using a different developer or toning agent. The process of converting the black silver into halides again is known as rehalogenising and it is for this reason that the bleach most commonly used comprises ferricyanide, a bleaching agent, combined with bromide. If the ferricyanide is combined with hypo its action is that of a reducer (page 77), in which the image is permanently removed as the ferricyanide bleach bleaches the silver and the hypo renders the unexposed halide soluable.

As the process of toning is usually carried out on an ordinary bromide print it is worth reiterating the precautions which should be observed during preparation of the initial prints.

The photograph should be enlarged to a reasonable size as hand work with a small brush or cotton

wool is easier when working on a large area. A good size is 20 x 16 ins. or 20 x 24 ins. although this may be thought too expensive. The development of the print must of course be carried out at the correct temperature 68°F and in fresh solution. Each print has to receive full and even development which ensures a good and rich tone in the later process. Even development is achieved simply by making sure that the print is quickly immersed in the solution and that agitation is smooth and constant. One cause of uneven development which may create trouble later is the use of too small a dish in which there tends to be greater turbulence of developer at the edges during agitation. Another is where an insufficient quantity of solution is being used.

It is also advisable that the density of the image be a little heavier overall than would be the case with a conventional print as the bleach and subsequent toning tend to cause a slight loss in image intensity.

Following development, the print is rinsed and fixed normally. Thorough washing is essential and for a double weight paper the washing time should be in the region of an hour with a number of changes of water. The print can either be dried at this stage or the process continued according to the time available.

If the print has been dried between washing and toning it must be well soaked so that the bleaching will be even.

The bleach used is a ferricyanide bromide solution and the toning agent sodium sulphide. There are some other bleach solutions and many other toning solutions all of which work well and offer a variety of colours. The various interesting departures from the conventional toning process which are possible and those discussed here are equally applicable to any method of toning. Sulphide toning is chosen as an example and, indeed, recommended because it is easy and reliable in use and produces a good sepia brown which combines well with black.

Page 62

Colours shown in this picture, together with some extremely delicate and subtle hues which inevitably suffer in the reproduction process, were produced by ferricyanide-bromide bleaching and sulphide toning. Further effects were obtained by choosing not to tone some areas, leaving them in their bleached pale brown colour, and by redeveloping other parts, which gave a slightly different black from the original. In addition some parts of the bleached image were fixed, which produced a very pale grey-fawn colour. The original image is of rock pools in the Yorkshire dales — *Nicollette Tait.*

Page 63

Cow in Northumberland landscape photographed on infra red film partially bleached and toned in places. A second image of the cow was mounted on the top surface of a piece of tracing acetate overlaid on the print. This created an interesting dimension in the picture owing to the diffusing effect of the tracing acetate — *Jack Tait.*

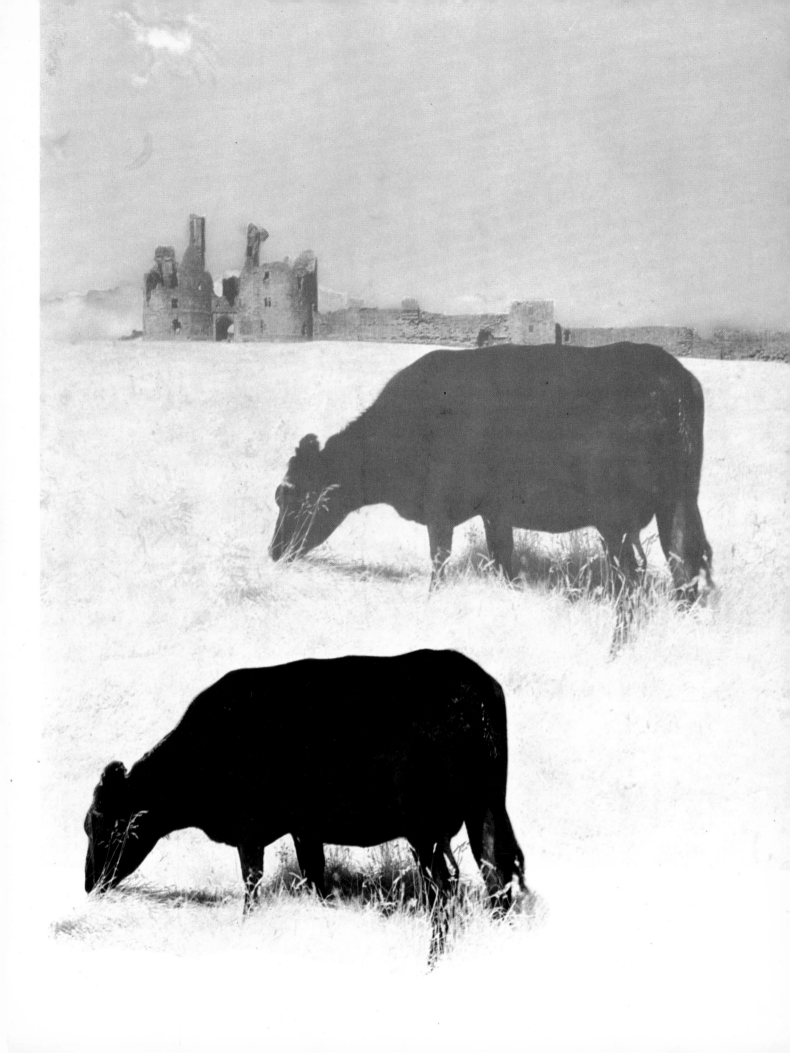

Bromide print prepared.

Image bleached in a potassium fer-ricyanide bromide bleach. Image may be partially bleached leaving some black silver.

Washing to remove all traces of bleach.

Toning by application of solution of sodium sulphide. Not all areas need be left bleached and may possibly be re-developed to a black. Bleached areas may, alternatively, be fixed to make them a very pale brown.

Colour coupling. Process begins as in toning but at this stage the print is developed in a colour developer to which a colour coupler and a dye have been added.

3A

Image control

At this point a number of alternatives are available which will affect the quality of the image:

1. Bleaching the print with ferricyanide bromide may give rise to a number of starting points for different treatments; The print can be bleached locally by means of brush or cotton wool application so that specific areas of the picture retain the original black. Alternatively, the print may be totally immersed in the bleach and partially bleached, leaving the deep shadow areas black. The final alternative at the bleaching stage is of course to allow the print to fully bleach and remove all the black. The pleasant thing about this whole method is that in many places the action is not final and it is possible to recover some of the black at a later stage if it seems desirable.

When the bleaching stage is completed the print should be washed briefly before toning commences.

2. Following the rinse, the toner may be applied in a number of ways which will depend on the effect required. The strength of the toning solution may be varied to control both the rate of toning and the intensity of the colour produced. If the toner is very dilute the subsequent image tone is of course pale and allows the colour depth to be built up gradually.

The simplest manner is to immerse the print in the solution and allow either the whole or remainder of the image to take up the toning colour so that the result appears either in one tone, or a colour and black depending on the degree of bleaching which took place.

3. A further method which employs a greater degree of control is to tone each area of the picture in a selective manner using a brush or small piece of cotton wool. Provided that the print is carefully squeegeed first in order to remove excess moisture the toning can be done with some accuracy. The main advantage of this method is that it allows two more alternatives.

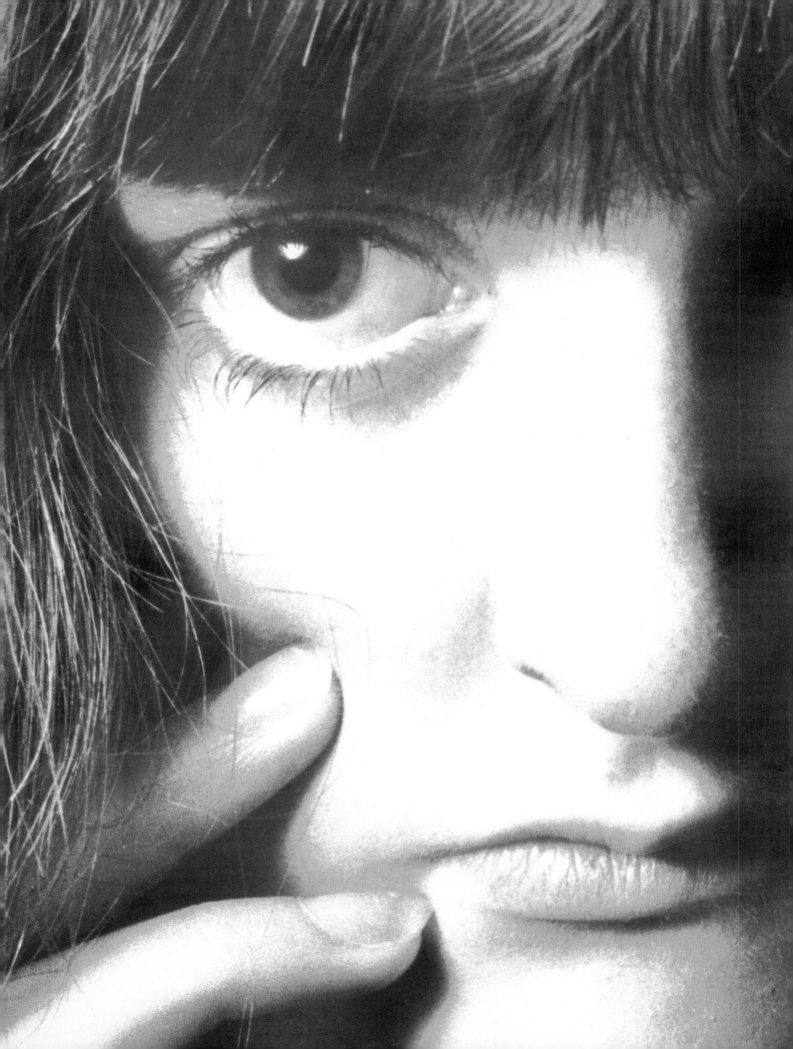

4. One alternative is to utilise the pale buff colour of the bleached out print. This gives a three-colour effect. The image may be made permanent by the application of fixer although a slight change of colour will occur under these circumstances.

5. A fourth colour is available by redeveloping some of the bleached areas with a print developer. The difference apparent between the original black and the new one is slight but discernible. This difference can be increased by the use of a developer which tends to give either warmer or colder tones than the original.

6. A final element of available control is to brighten highlights or lighten areas with a reducer such as ferricyanide and hypo. This may be used to alter the tonal relationships of individual areas if applied with care. This is best done with cotton wool on a squeegeed print, and it is most important to ensure that no drips of the solution are allowed to fall on the print.

Precautions

In the above descriptions of toning techniques it has been taken for granted that, between each stage, absolute cleanliness is maintained in respect of washing brushes and using fresh cotton wool for each different activity. Following each stage of work on the picture the areas under treatment should be rinsed to prevent any cross contamination on the surface of the print.

Provided that the basic methods have become familiar and it is possible to use them in a controllable manner, there is no reason why deliberate contamination and the resulting stain effects should not be pressed into service as an alternative system of extending the range of colour available. This method may be applied to an otherwise plain background if some tone variation or texture is needed in a certain area of the picture. The results of the above give rise to a range of colours and tones which are extremely delicate and close to each

The original bromide print was left in exhausted thiocynate fixer for an extended time (up to 12 hours will do). This caused the semi-bleached/toned effect — *Colin Shuttleworth.*

other in hue and the subject chosen on which to attempt them must be appropriate to the technique. The chief attraction of the methods just covered is that they offer a means of carrying out a very subtle modification to the basic photographic image which is capable of results of great beauty. It is undoubtedly a fine print activity as many of the subtleties would be lost in all but the best photo-mechanical reproduction. Broader effects using rather more of the spectrum are offered by the colour coupling process although there is a vast scope in this area for further experiment with other methods of toning which generate blue, green and red tones instead of the brown given by sulphide. The imaginable permutations which offer themselves by means of combining two or more toning methods are almost infinite and capable of much further exploratory work.

Whilst the formulae for the solutions described above are set out below, full descriptions for routine toning and colour coupling materials are available in numerous books as well as in the instructions supplied with proprietary brands. If any length of time is to be spent toning prints it is essential to wear protective gloves. The chemicals have a tendency to soften the skin on the fingers particularly where areas of the print are being rubbed with cotton wool and this damage to the skin can produce cracking and bleeding which is very painful. In addition the sodium sulphide has a very strong and unpleasant smell and is best handled in a well ventilated room. A formula for sulphide toning solution is given on (page 143).

Toning by colour development
In the description of toning given in the previous pages it was implied that in addition to the brown colour available from sepia toning there were other methods of obtaining colour and these were capable of generating blue, green and red, the procedures being similar.

If the particular colour to be produced is of more importance than the exploitation of the working method, then it is better to use a system of producing colour which offers not only purer colour but also a greater facility for colour contrast.

A method which offers the above advantages is the process of toning by colour development. This process works in the following way: the usual starting point is a bromide print, although film may be used instead. The bromide print is produced in the normal way in the initial stages and if necessary the process may be halted at this point. (It is possible to bypass this conventional stage altogether and colour develop immediately, although this is not recommended as some of the control is forfeited.) In the production of the bromide print the same care must be taken to ensure that exposure and development are full and carried out in fresh solutions. The next step in the process is the bleach, just as it was in the sepia toning method (page 65), and the silver image is removed by the ferricyanide bromide solution. As explained previously this makes the paper sensitive to light once more and following a thorough wash the paper is fogged by strong room lighting. At this point the image is now ready for development but instead of a conventional 'black and white' developer, a colour developer is employed. To this colour developer are added colour coupling solutions and according to the number and proportion of couplers used the required colour is generated (see table). The colour developer itself acts on the image and in developing this to metallic silver, development by-products are formed. These by-products combine with the coupling solutions during development to produce a coloured dye which is formed in proportion to the silver which is being developed.

There are three basic dye couplers used, yellow, magenta and cyan and obviously they bear a close relation to the dyes and colours used in many colour materials. A wide range of colours is obtained by

adding different proportions of these dyes. The process described above lends itself to modification and offers much scope for unconventional usage. Formulae for toning by colour development are given on page 143.

Applications

There are a number of ways in which the colour toning method may be used:

The first choice presented to you in colour coupling arises out of the natural working of the colour developer. It was explained that the colour was formed by the interaction of the development by-products and the colour couplers and that during that period of time a silver image was also produced. This silver image remains under the dye image and can be either left or removed at will. When present, it reinforces the density of the image giving it strength and, at the same time, subduing the 'sharpness' of the colour. This silver image may be removed entirely or partially in overall terms or it may be locally reduced in order to introduce a further colour variety.

If the idea of using hand work on the image is acceptable and possible then individual areas may be separately bleached with a brush or cotton wool. Following each local bleaching a different colour may be produced by mixing separate colour developer and coupler solutions. To avoid unwanted running of one colour into another each separate area should be washed and the body of the print kept in a damp, but not wet, condition by the excess water being squeegeed away.

Thirdly, if the process is modified earlier there is the scope for partial, overall or local bleaching of the original bromide print. This is different from the bleaching mentioned in the first paragraph as the original silver is much blacker, and, where the black silver remains no colour can be formed. The visual appearance will therefore be one of black/grey side by side with colour as opposed to a

Seascape shot on an extreme wide angle lens and colour coupled with meticulous care — *Howard Kingsnorth.*

71

weaker black/grey under the colour dye.

If the original material consists of large sheet film instead of bromide paper then a picture may be built up from a number of layers and each layer may be one colour overall or selectively dyed in a number of colours.

Finally the image at the bleached stage may be left as it is — a pale buff colour — or it may be reconverted to black silver by application of an ordinary black and white developer.

In conclusion, it has been shown that if the range of colour available from the three secondary dyes, yellow, magenta, and cyan is permutated with the range of tone available from black to white as the original bromide print then reasonable scope exists for exploratory modification of the photographic image. These techniques are particularly suited to work with stripping film and collage as described later.

Bromoil

The bromoil process bears a resemblance to lithography in that it relies on the antipathy of grease and water to achieve the final image. Unlike toning and colour coupling where the image was reformed in colour by chemical means, the bromoil process allows the colour to be put on to the paper surface manually using special brushes. The photographic paper is prepared so that the original silver image accepts a greasy ink whilst the non-image areas absorb water and repel the ink. The chief advantages of this method are that as much or as little of the image may be 'inked' leaving the remainder as white paper, and the brushing technique used lends a particular character to the final image.

The process is begun in a similar way to toning and colour coupling in that a bromide print is used as the starting point. There is however, one important difference and this is in the type of bromide paper and its surface. In the conventional bromide paper the emulsion, that is the light sensitive coating, is covered by a further coating of clear gelatine known as the supercoat. The purpose of this 'supercoating' is to offer protection against abrasion both during the wet processing and when the print is dry. As the bromoil process relies on the use of a relief image formed by the light sensitive emulsion it is essential to use a paper which has not been supercoated. Such paper is available from at least one manufacturer as a matt art paper. Once a suitable paper has been obtained the image is printed and developed but not fixed in the normal way. The print should be of decidedly lower contrast than a conventional bromide print, having full detail in both the highlights and shadows. As in all proces-

Page 74
In this profile the hair occupied the major area but it was decided that the important part of the image was the outline. Accordingly, the ink which had been brushed into the middle was removed with white spirit and the pale grey texture was left in place —*Jack Tait.*

Page 75
A two-colour bromoil with the colour relating to the tonal areas of the original image. This demonstrates the basic flexibility of the process —*John Fisher.*

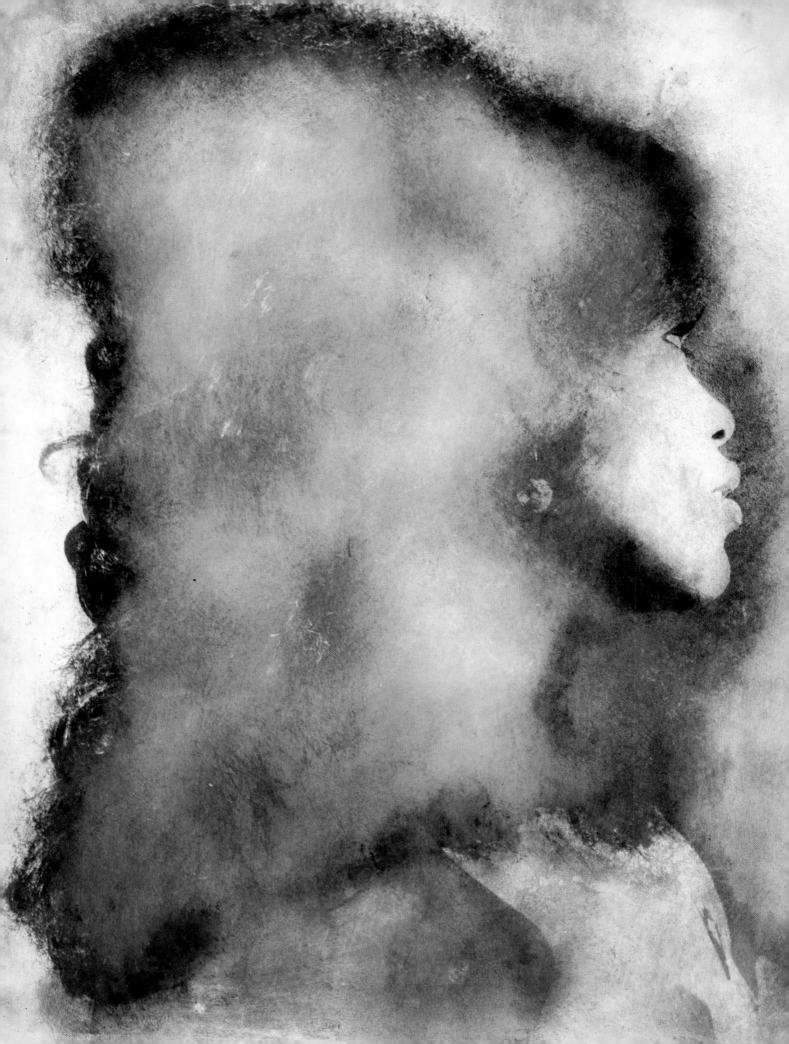

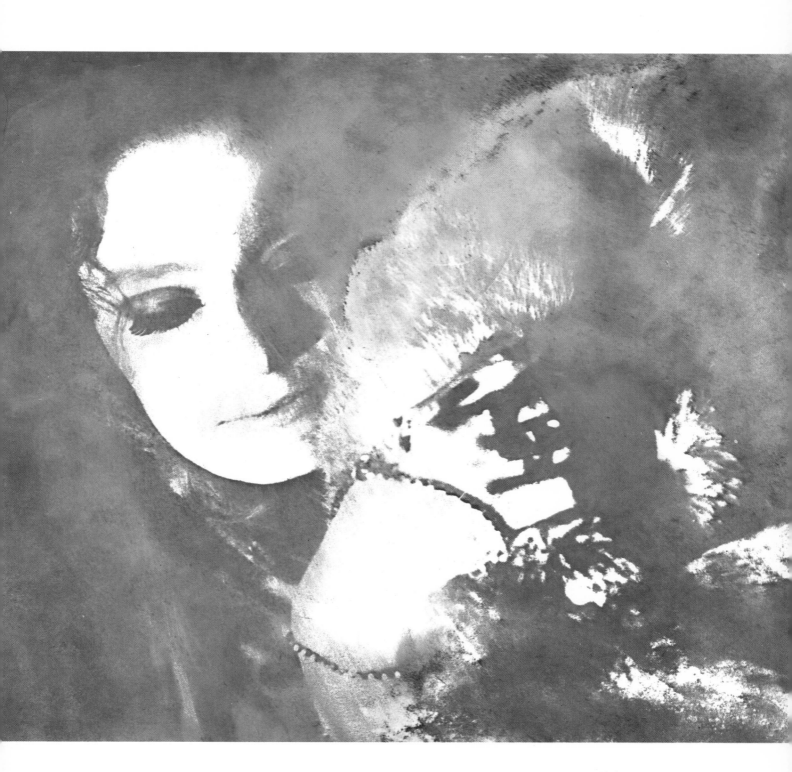

Bromide print made on non-supercoated paper but developed in normal way.

1

Print washed and fixed in plain hypo 20% solution.

2

Print dried.

3

Bleaching and tanning. Following exposure, the print is bleached in the copper sulphate tanning bleach which creates a relief image capable of absorbing ink in the image areas and repelling it in the non-image parts.

4

Washing and fixing – again in plain hypo 10%.

5

Drying – print dried.

6

Soaking. Print soaked in hot water to swell the tanned gelatine image.

7

Inking. The ink is put in by brush. A number of colours may be introduced at this stage. The ink adheres to the image areas and is repelled by the water retaining gelatine. This is not an easy process until some skill is acquired in brushing in the ink.

8

76

ses the print must be developed in fresh developer for the full time — two, to two and a half minutes and of course, at the correct temperature — 18°C. Should the negative produce too high a contrast on the paper then some control can be exercised by diluting the developer to half its normal working strength. After rinsing the print (following the development stage) the print must only be fixed in a solution of plain hypo (20% solution). This is quite different to normal practice when the fixing bath is either acidified or is of the rapid fixing variety. If any other fixer than plain hypo were used the quality of he relief image would be impaired.

After fixing for five minutes the print is washed and dried in the normal way. An advantage of this method is that it can be interrupted at this point and the bleaching carried out at any time afterwards.

Bleaching
The bleaching has been found by the author to be fairly critical in that many initial difficulties in the inking have been attributed to this stage. Each worker will doubtless find the method which suits him best but it appears that bleaching is best continued only up to the point where the silver image has disappeared. For ease of repetition a fresh solution should be used for each print and the temperature maintained at 18°C. The purpose of the bleach solution is to remove the silver image and at the same time a tanning action takes place. The tanning only occurs in the gelatine in those places where the original silver image was formed and the normal water absorbent qualities of gelatine are changed by the copper sulphate so that they now repel water and are able to accept ink.

The bleached print has to be thoroughly washed in a number of changes of water and then fixed again in a weaker plain hypo solution than before, (10%) for three minutes. The print is then washed and dried completing the second stage of the process at which the work may be left until another time when the ink is to be applied.

Page 78
It was felt that the hairy coat of one of our Afghans, Mooski, would lend itself to the bromoil process —*Jack Tait.*

Page 79
The very delicate effect in this picture of thistles shot on infra-red film was obtained by inking the image more heavily than finally required and then removing it with an almost dry brush —*Jack Tait.*

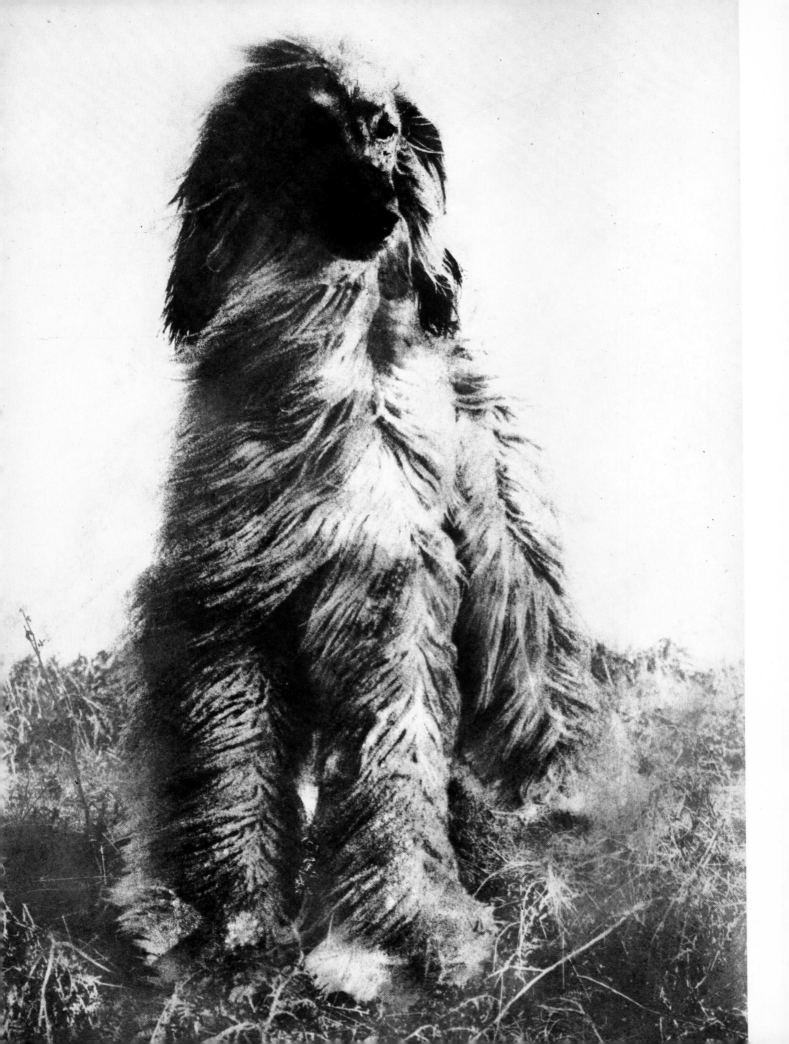

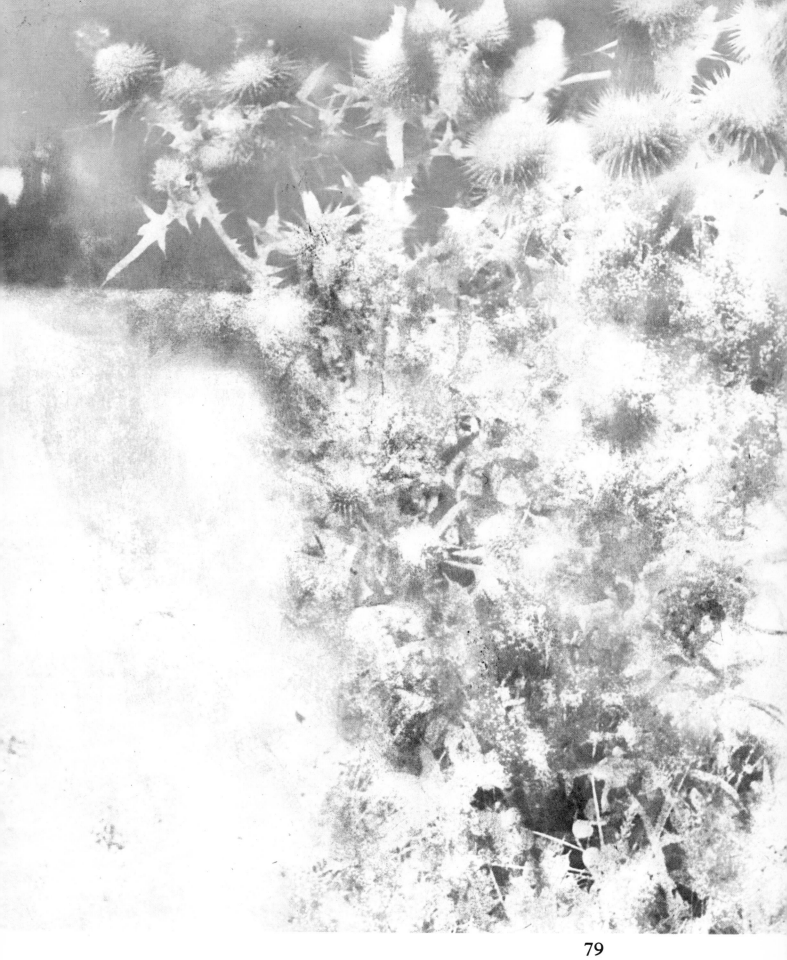

Pigmentation

The last stage in the bromoil process is the pigmenting of the print by greasy inks using a special bromoil brush. Litho inks can be used but these are inclined to be too soft and have a tendency to adhere to the highlight areas.

To prepare the print it must be soaked in warm water (20–25°C) for thirty minutes. Moisture is then wiped off with clean chamois leather. The inking is begun and at first only the deeper heavier tone areas of the print should 'take'. When some inking has been carried out the print will have dried out a little and should be resoaked for a few minutes before the next inking. If the shadow areas have been completed, the next areas may be inked using softer ink and the cycle repeated until the print is finished.

One very common trouble which can occur is that the ink occasionally has a tendency to take on the white areas and rebates. This surplus ink can be removed in the soaking — if persistent, the area may be lightly rubbed with the chamois or by hand when the ink will float off. It is best to choose the image for bromoiling carefully as at first it is difficult to reproduce any fine detail satisfactorily. This is because a certain amount of manual skill is necessary and it takes time to develop. An image with clear cut areas of light and dark with a few midtones is easiest to work with and should preferably be carried out on a fairly large paper size in order to minimise any small errors.

Dye Transfer

The Kodak dye transfer process was developed primarily to make subtractive colour prints and it is capable of producing prints of the highest quality. In this chapter the orthodox process is described but its application limited to placing one or two colour images on paper, as opposed to three — and not necessarily in the subtractive primary dyes, yellow, magenta and cyan. The advantage of using the process in this way is that the highest quality colour images having a full tonal range may be placed either on transfer paper or on a conventional bromide print having a 'grey' silver image on it. A further advantage, which is not readily available with the toning colour coupling or bromoil processes, is that it is possible to produce a number of identical copies as the image is transferred from a relief gelatine image which can be dyed many times.

In the dye transfer process a conventional monochrome negative is printed in the enlarger on to a film instead of a paper. This is coated with a *blue sensitive emulsion which differs from conventional film in that it is unhardened and also contains a yellow dye.

A further unusual characteristic is that the film must be exposed through the base as a relief image is needed. This means that any part of the image which received exposure is in contact with the base and when the unexposed emulsion is removed the image will not fall off its base. The function of the yellow dye in the film is to govern the amount of exposure which the film receives throughout its depth so that the emulsion close to the base is exposed quickly whilst the emulsion furthest away

Pages 82-83 and 86-87

All the illustrations for this part of the chapter in dye transfer were made from three monochrome photographs taken in a wood. Two of the three were double exposures, one of which had camera movement deliberately introduced (see main image of tree trunks). By limiting the images to three it was intended to show that a variety of different pictures may be made from relatively simple beginnings provided that the images chosen lend themselves to the process. The only variables employed were (i) the colour in which each image was printed (special colours were mixed in some pictures which offered rather more subtle effects from those available from the standard yellow magenta and cyan) and (ii) the use of a black or bleached brown in a bromide print as a base to which colour was added —*Jack Tait*.

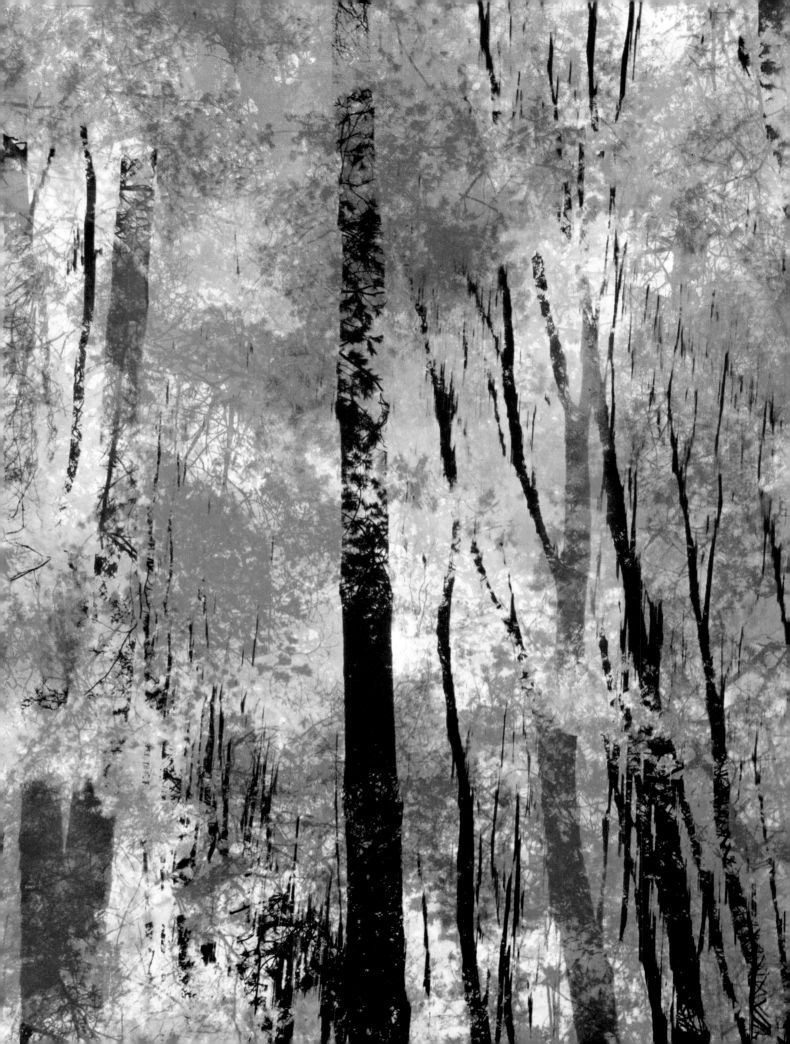

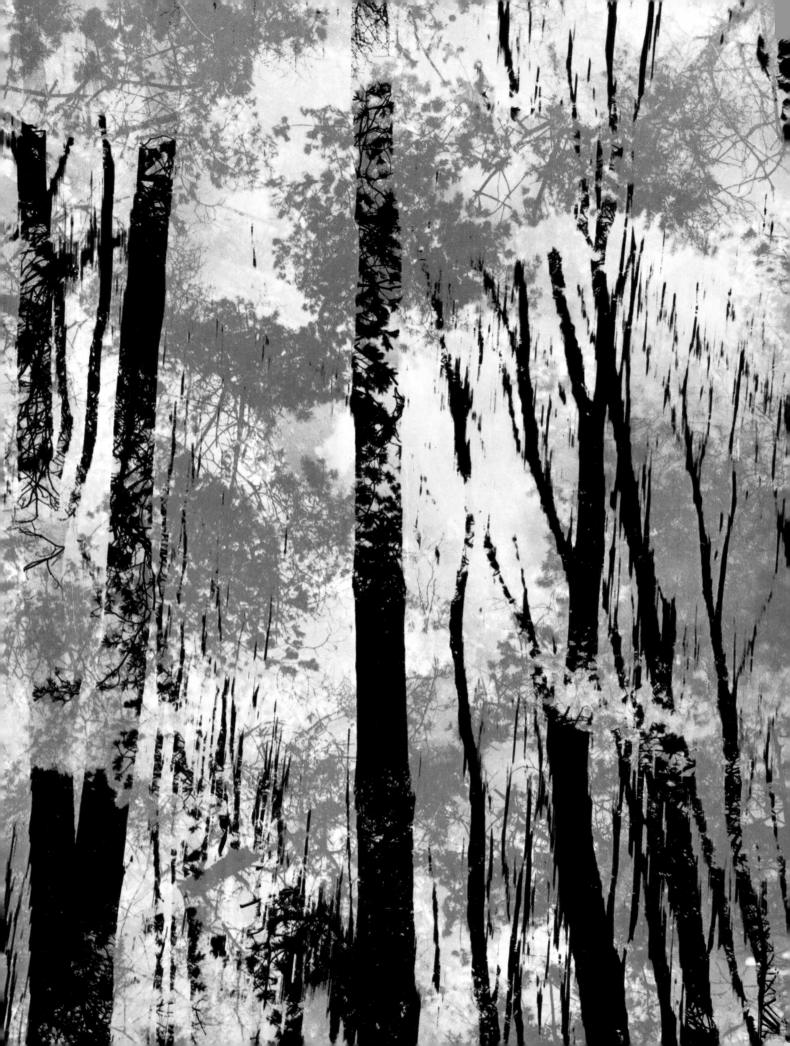

from the base takes longer as the blue light must pass through a large quantity of yellow dye. Therefore the more light that falls on the particular area of the image the further down will the emulsion be exposed and a relief image will be produced whose depth is directly proportional to the intensities received from the negative.

The next step is to harden the gelatine of the exposed emulsion. This is achieved by a special developer in which the normal oxidisation by-products are not rendered colourless but used to effect the hardening of the exposed gelatine. When the hardening process is complete the remaining gelatine which has not been hardened is washed off in hot water. When only the hardened gelatine remains the film is dried and is then ready for dyeing. The film is immersed in a coloured dye and the relief image absorbs dye in proportion to the depth of gelatine. The gelatine coated transfer paper or bromide print has first to be prepared by soaking it in a paper conditioner solution. The film, or matrix as it is termed is soaked in an acetic acid solution. After the print has been drained, the paper and the dyed film are brought into contact and squeegeed together, the colour image transfers from the film on to the paper and the process is complete. The film may be used again, and the paper is ready to receive another image, or be dried. It is very important to heat dry the print as quickly as possible after transfer as the image tends to 'bleed'.

The two methods of employing the dye transfer process are described in detail below making some references to the unique facilities which they offer if you wish to modify your images. The first, as mentioned above, is to lay down a number of coloured images on gelatine transfer paper. The finished result will have the appearance of colour print but with the added control over the positioning and subject matter of each layer. The second method is to begin with a basic grey image on bromide paper and add one or more coloured images to it.

*Panchromatic film is available but the blue sensitive is cheaper, easier to use and quite adequate for the purposes described.

Method 1

Initially it is best to start with only two images. These should be carefully chosen so that the optimum range of colour is produced. They should compliment each other, producing a simple but definite visual effect. For example, one image might be a face or a building having fairly large areas of specific shapes which will stand out well against a number of different backgrounds. The second image might be more of an overall texture or pattern which has a complete range of tone within it. It is important that both images have a complete range of tones well distributed over the picture area for a maximum colour range to be achieved.

The variety of colour available from any two dyes is in direct proportion to the number of their permutations. For example, one colour is produced by adding 10% of colour 1 to 90% of colour 2; another in the proportion 20%:80%; another 50%:50% *and so on until through the whole gamut*. This is only possible if each image can carry the range of dye from zero to maximum and if many of the intermediate preparations coincide in the over-printing. It is for this latter reason that the suggestion was made to have the second image as a texture. This means that it can be printed in two ways if a rectangle and four if a square. By over-printing the second image in different ways the range of colour produced will be changed whilst the visual appearance of the image will be altered less, particularly if this second image is textural in form. Once it has been realised that two colours offer a vast range of intermediate effects owing to the excellent continuous tonality of the material it is possible to add other printings. It is advisable to think of some, if not all, of these images in terms of simpler 'flat' images having a restricted tonal range so that the combined effect does not become visually chaotic. An excellent method of producing ancillary images for dye transfer is to employ photogram techniques. These give scope for great control and subtlety. With the facility which the process offers it

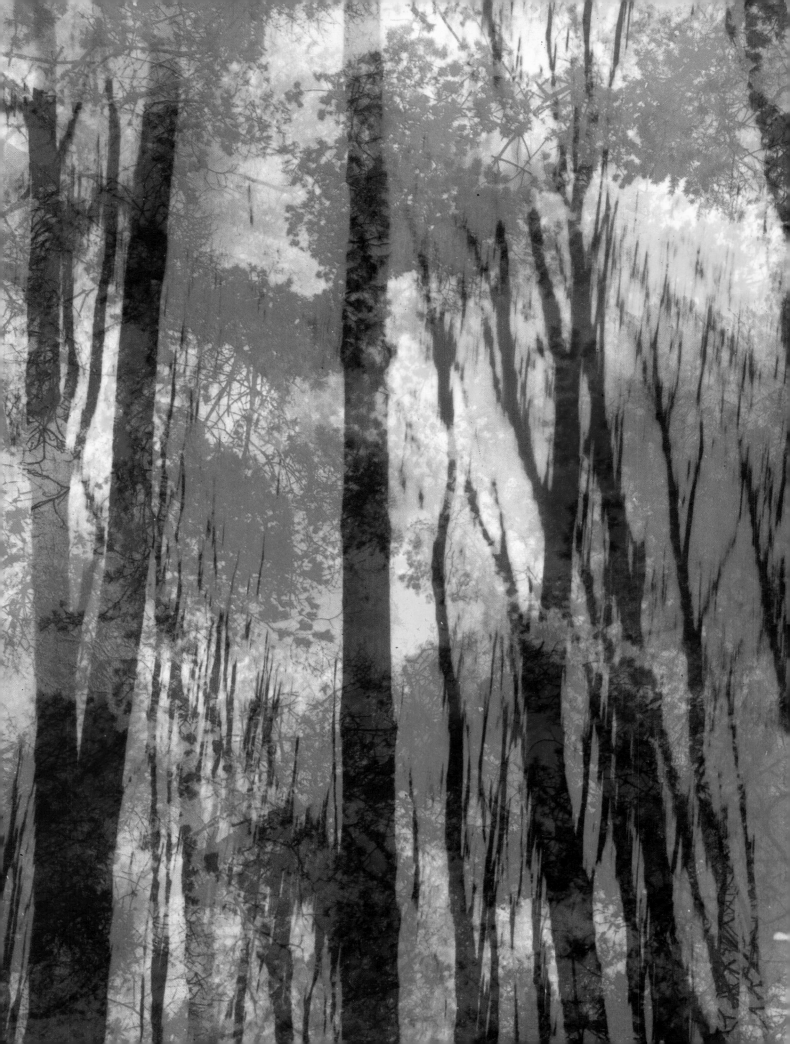

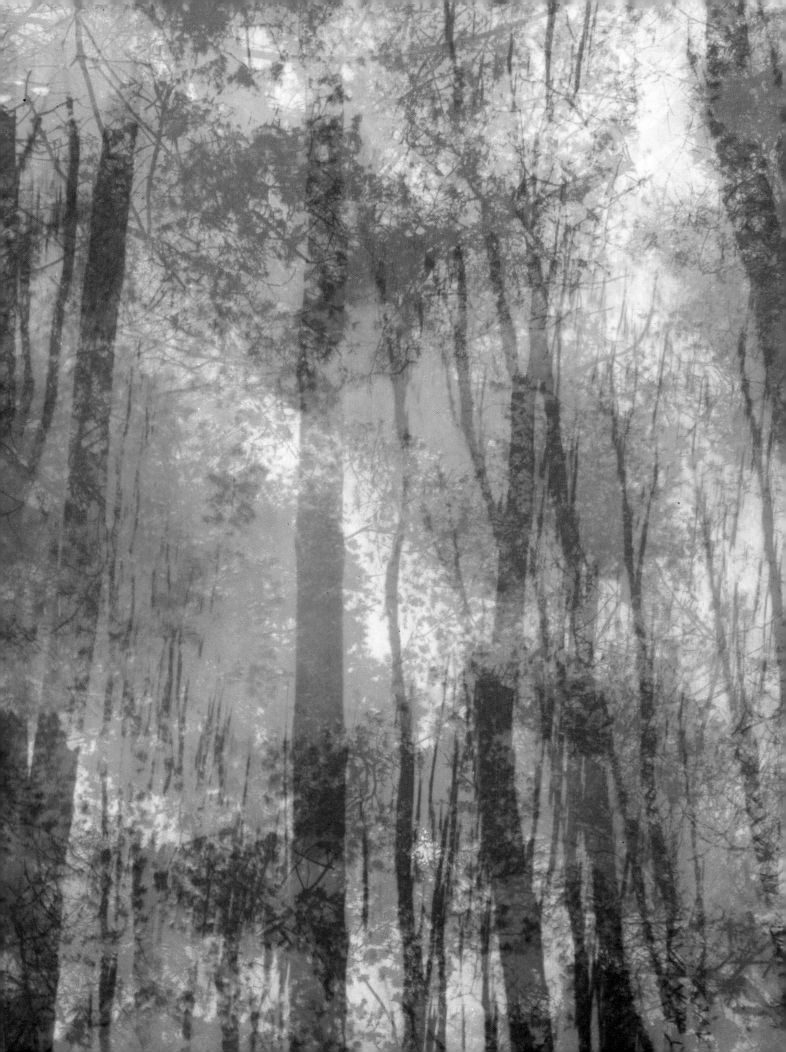

Original negative.

1

Printed on to matrix film which is placed on the enlarger upside down and exposed through the backing.

2

Developed in a tanning developer which hardens the gelatine in proportion to the amount of exposure received.

3

Hot wash. The unhardened gelatine is washed off in water 110°–120°F and a hardened gelatine positive image remains.

4

Dyeing. Usually the matrix is dried at stage four and, before dyeing, it is recoated in warm water to swell the gelatine. The image accepts dye and is fully dyed in 5 mins. with agitation.

5

First acetic rinse. Following dyeing, the excess dye is rinsed off in a solution of 1% acetic acid and the acid is then discarded. Time 30-45 sec.

6

Second acetic rinse. This bath is termed a holding bath and is 1% acetic acid. The martrix remains immersed until ready to print.

Paper conditioner. Meanwhile the paper (either the bromide print or the dye transfer paper) is immersed in the paper conditioner for 30 mins.

Printing. The matrix is drained off from the holding acetic bath and squeegeed into contact with the paper, which has been very thoroughly roller squeegeed on to a flat surface. It is very important to ensure that no excess conditioner remains on the paper as this causes bleaching of the dye and can ruin the whole print if it occurs at a late printing stage. Equally important is absolute cleanliness — no cotton wool used for swabbing off conditioner must ever be used twice and any contamination of acid conditioner or dye is disastrous. Time in contact, 5 mins.

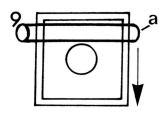

Drying should take place immediately the matrix is removed — prints or bromide paper should never be washed in water, only in acetic acid solution if glazing is contemplated.

Matrix washing. The matrix is washed in warm water and either dried or the process repeated.

is possible not only to produce many variations simply, but to develop an idea over a period of time adding another colour to a picture some months after the first.

Method 2

Many of the methods described in this chapter have dealt with ways of augmenting the straight bromide print, without losing any of its intrinsic qualities. Toning and colour coupling methods change the basic structure of the silver image in order to introduce colour. In the bromoil process the colour is added by hand to what should have been a bromide print. Only by using this transfer process can colour be added to the black and white bromide print in a way which retains the pure photographic image qualities yet offers easy and precise control. Just as a wide range of colour is given by the combination of two colours, the combination of a perfect grey image and a colour will generate an equally exciting range of subtle effects. If other colours are required without preparing further matrix films the colour image can, of course, be printed a number of times, particularly in the case of a texture, and in a different colour each time. Moreover the bromide print could have been partially toned first to introduce a further colour. There is no limit to the combinations which may be suggested, but perhaps the most effective way to use this particular method is to apply only very small quantities and areas of colour to what would otherwise be a conventional black and white print. Kodak Ltd publish full working details of the dye transfer process which uses their materials.

Stripping Film

Besides altering or recombining the silver image produced by the photographic process, it is also possible to modify the image by adjusting it in a mechanical way with collage. This technique is wholly involved in a concept of selection and rearrangement of parts of a picture. There are at least two main approaches to it. An image can be distorted mechanically if it is on a flexible support. Images can create a total environment which would involve both slides and moving images combined with sound. Here we are concerned with the first suggestion — that is, the concept of mechanical distortion of the image and some of its potential applications.

The ideal material for this sort of experiment would of course be a light sensitive emulsion coated on an almost infinitely flexible rubber type support.

It is technically possible to coat an emulsion on a rubber support but unfortunately this would be difficult, time consuming and expensive. At the present time to the best of the author's knowledge no such material is freely available on the commercial market. There is, however, one 'graphic arts' material called stripping film which possesses some of the advantages of the ideal material described and which is easy to use and obtain.

Stripping film, as its name implies, consists of an emulsion which can be separated from its support following exposure and processing. The separation may be performed either in the wet or dry state depending on the manner in which it is to be used. The emulsion is orthochromatic, it is sensitive to blue and green light and may be processed under

Print image on to film (b) whilst attached to backing (a). Process in lith developer, dilute print developer or soft working film developer, according to contrast required.

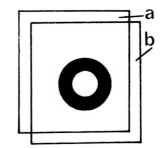

Distort the image at either the wet or dry stage, leaving it in contact with the backing. If permanence is needed use special adhesive to fasten the film to either the backing or an alternative support.

Recopy if step and repeat of image is required.

Print on to more stripping film and continue process of distortion. At this point the image may be toned or colour coupled.

Tear or collage results in further variety and scope. Fix with adhesive and recopy if necessary.

Copy collage on slow ordinary film (i.e. blue sensitive) and process in soft working developer to keep the contrast low.

1

Images A. B & C cut or torn into collage form and mounted with adhesive such as Cow gum.

2

Enlarge the final image.

3

First negative (A) registered on the layout paper on the enlarger baseboard.

4

Original print material.

1

Test strip for correct exposure.

2

Print on bromide paper masking top right hand corner * and registering paper on pins (i).

3 (i)

Place this exposed print in a light-tight box.

4

Second negative (B) registered on layout paper.

5

Test strip for neg B. Choose density to work with that of test A.

6

Print B on to paper where the A image was exposed. Process as normal.

7

(*See also chapter on masking)

94

Two identical films were colour coupled and bound up emulsion-to-emulsion so that a completely symmetrical image resulted except for one of them being deliberately torn and moved slightly — Jack Tait.

illumination from a red safelight. According to the result required the exposed film is processed either in a 'lith' developer or in any of a number of continuous tone developers. As a full range of tones is usually wanted it is recommended that you use a bromide print developer or, for very soft results a fine grain film developer, in which the contrast can be governed slightly by the development time. For the most effective result it is best to begin with an image whose departure from the normal can easily be judged from the finished result. The most simple method, and the best to start with, is to use the stripping film on the enlarger baseboard so that the images produced are, like prints, enlarged positives. The result will have to be viewed after transfer either as a transparency or placed on a reflective support. For many purposes this is quite satisfactory and the film can readily be toned or colour-coupled before transfer if it is to be viewed as an original.

Following processing it is suggested that the film be stripped wet and transferred to a gelatine-coated paper support. Ordinary fixed out bromide paper will do quite adequately although Dye Transfer paper is cheaper. Before the film dries it should be manipulated into the desired positions. Provided that the image is not too contrasty or too dense the presence of folds in the image will enhance the appearance. A further possibility to be applied is to fragment the film slightly as this allows some image rearrangement.

The next logical step in using this material is to overlap one image with another, transferring the second on to the first either after the first is dry and fixed on to the support, or when both are wet, if you are prepared to take the risk of disturbing the first. These images may be coloured or toned again in order to extend the scope.

Cumulative distortions

A more complicated method of using this film is to make it an intermediate step in a longer process

Right
A collage on a paper base using black silver and brown colour-coupled images —*Jack Tait.*

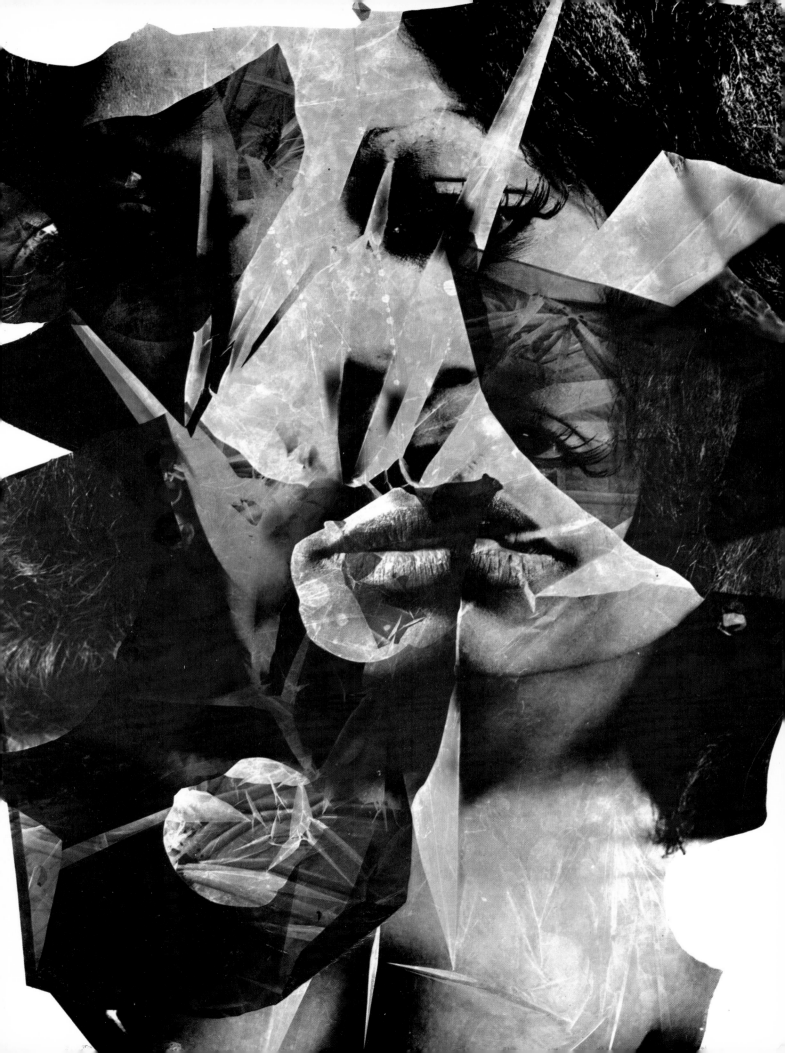

where it is both possible to keep on adding distortion to distortion and where finally any number of copies may be made from a 'master' negative. In this case the first step is to make a small flat positive from the original negative on conventional film such as Ilford N5 31 or Kodak CF8 processed as recommended on page 117. The reason for this is that an increase in contrast is difficult to avoid and starting with a flat result allows of more steps in the process. The positive is placed in the enlarger and from this an enlarged negative made on stripping film. At this juncture the film is stripped, transferred, distorted and when dry may be contact printed and positive prints made from it. If the process is to be continued the negative is made on a smaller piece of stripping film, treated, and then printed in the enlarger on to more stripping film. The number of repeats possible is actually limited by the level of contrast which can be accepted. If it is thought that extreme contrast does not detract from the image then any number of repeats are available.

Finally, stripping film being very thin and flexible lends itself to uses on simple three-dimensional surfaces such as moulded plastic or fibre glass shapes. This application increases the scope of the material and is the only simple method of placing a photographic image on rounded surfaces. In addition, as it is capable of being developed in 'lith' developer to a very high contrast its use could be extended to acting as a mask for a photosensitive resist. This would have very interesting applications in the field of ceramics and stainless steel etching where the subject was not a flat surface.

Multiple Printing and Collage

Two of the extraordinary and interesting aspects of photography as a graphic process are the ease with which it is possible to bring together a variety of images on to the same piece of paper or film and the accuracy and conviction of the photographic image as a representation of reality. The former advantage makes it possible to overlay one image with a second and in the act of being brought together each alters the other's characteristics. It is no problem to investigate the visual effect of a landscape picture of the earth taken from a satellite being overprinted with a microscope picture of a cross section of a minute seed. The second allows mechanical juxtaposition of realistic pictures to create images which would not normally exist. Both techniques mentioned above rely on some deception to the eye, often presenting an image which is initially seen to be impossible as our senses are conditioned to interpreting the photograph as a believable rational entity. The surprise value and impact stemming from collage and multiple printing offers another quite different outlet for explaining visual ideas by means of photography.

Multiple printing

The simplest and quickest way to achieve a multiple image photograph is to take two quite conventional negatives and print them in turn on to one piece of bromide paper. Each negative has to be tested first to establish the optimum exposure and some system devised to allow accurate registration of the second image with the first. When the test strips are examined it must be remembered that the densities on the images will be additive and two

greys overlaid will generate a dark tone. It is important to reduce the exposure on each image so that the whole range of tones which the paper is capable of producing is preserved. This part is relatively easy to accomplish, the most critical aspect being the registration.

Registration

Accurate registration of the images can be achieved by following the procedure.

The first image is placed in the enlarger and projected on to a large piece of card. At two opposite corners of the card a drawing pin is pushed through, point uppermost, to act as a registration pin. This card must then be taped firmly on to the base-board of the enlarger. A sheet of white layout paper is then pressed over the two pins and should be large enough to more than cover the image area. As the pins will pierce the paper with two small holes it can thereafter be placed in register at will. The first image is sketched in soft pencil on this pad and the top right hand corner marked. At this point the layout paper is removed and the test strip exposed. Following exposure assessment the bromide paper is pressed on to the pins and exposed, care being taken to mark the top right hand corner on the back of the print so that it may be replaced both the right way up and in register by means of the pin holes. After exposure, the bromide paper is stored. The layout paper is replaced in register and the second image substituted for the first. The first sketch is used as a guide to composition. The second image is sketched over the first drawing in a colour if preferred so that the combined effect may be judged. Once a satisfactory solution has been arrived at a test strip is made and the bromide paper is positioned in register, in place of the layout paper, and exposed. The multiple print is now ready for development. The above procedure must obviously be repeated until a satisfactory image is made. It is very helpful in the interests of speed if the rapid

A colour print where the model was photographed in front of a mirror and the flower image was placed in the mirror image part by masking — *Peter King and Jack Tait.*

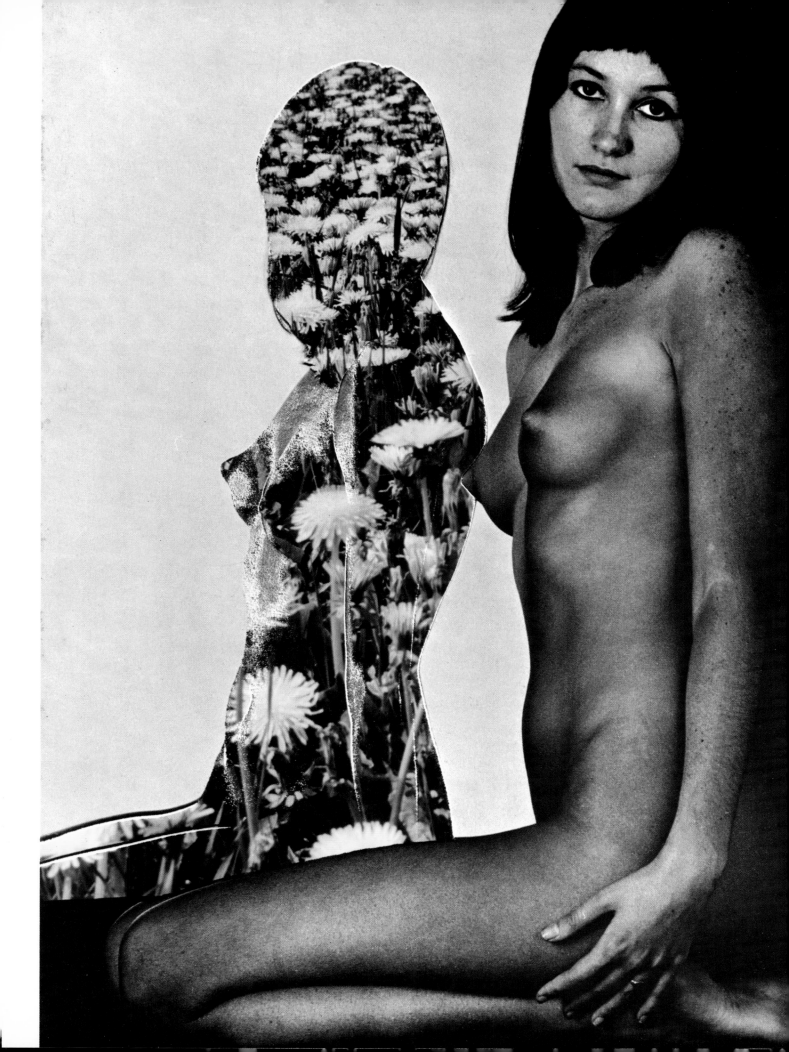

access process is used for multiple printing as each print is processed for nine seconds instead of three minutes. A number of proprietary machines are available which automatically develop and stabilise prints very quickly. The bromide paper for this process is specially impregnated with developer which is activated on contact with the first processing solution. The second bath simply stabilises the image, making it safe to view in daylight and reasonably permanent. The results may be fixed in weak fixer, washed and dried in the normal way at any time. In the interests of economy the paper and chemical alone may be used in dishes provided that wet, as opposed to damp, prints are acceptable. A further solution is to build a simple rapid access processing machine.

The straightforward method of multiple printing which has been described above is capable of being augmented to achieve more control and a greater variety of effect by the modifications described below.

It was recommended above that two conventional negatives be used in the initial stages. The first alterations may be introduced by making one or both images with very high contrast, producing duplicate negatives on 'lith' film.

The advantage which acrues from this is that as the images will print 'flat' in one tone only, the combinations of two images are simplified. This also means that the same 'flat' image may be printed more than once. If this idea is followed through, a large number of 'lith' or screen images can be overprinted without the identity of each being lost in a jumble of different tones. In addition both negative and positive images of the same or different subjects may be combined in the way just outlined. A further extension of this technique, as will no doubt have occurred to the reader, is to combine photograms with negatives in the enlarger in order to produce multiple images.

Partial modifications

So far, the suggested modifications have been mainly confined to the negative stage and have involved only changes of the component images and the form in which they are employed. What is discussed below is a precise change in parts of one or both images. These precise changes involve using accurately registered masks to allow parts of the first image to be masked out and the second image to be placed in the space left by the mask. The final appearance then gives the impression of one continuous image but having the visual impact of two pictures combined. In order to be able to describe the above procedure coherently it is essential to give a specific example.

One idea which once captured the interest of a number of people working in the School of Photography at Manchester was that of reflections in mirrors. A photograph of a girl before a mirror was taken as the primary image where the camera was angled over the model's shoulder into the mirror and its reflection. The second image was that of a texture of flower blooms in which the object was to substitute only the reflection of the girl for the flower texture. In the lighting of the original photograph care was taken not to light that part of the girl's face and body which appeared in the mirror and to ensure that the dark reflection was surrounded by a light tone. The purpose of this was to facilitate the separation of the mirror reflection image when the masks were being made.

Enlarging

The first step following the initial shooting is to place the negative in the enlarger and bring the image up to the right size. At this point precise details of the settings on the enlarger must be made so that the same degree of enlargement can be reproduced in the future. This can be easily achieved by projecting a piece of film with a one inch slot cut in it on to the baseboard where the

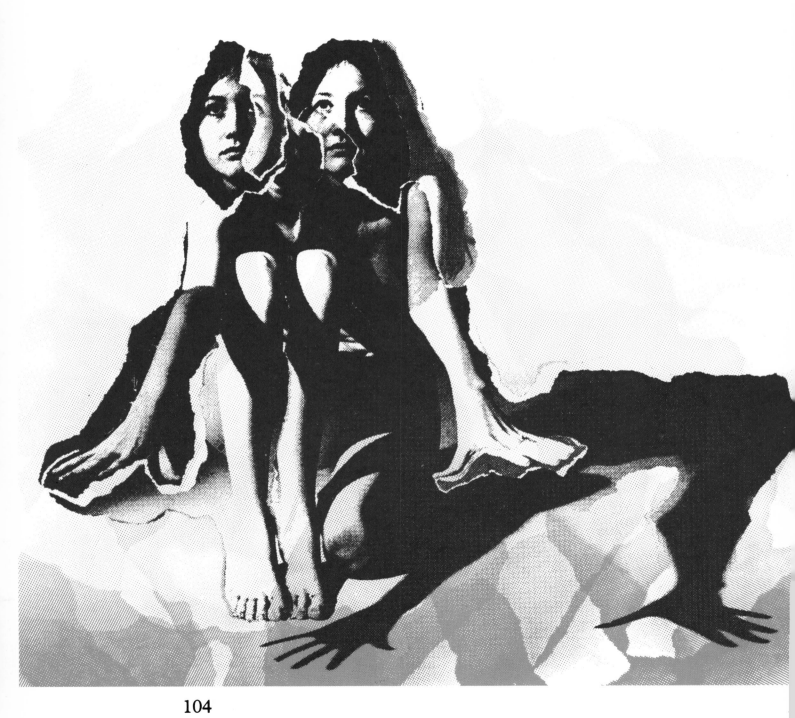

104

image can be measured thus showing the exact magnification. For example, a four and a half inch image of a one inch slot would indicate a four and half times magnification. To be doubly sure of repeatibility the enlarger setting should not be moved or altered throughout. On the pin register base (described above) an image should be exposed on to 'lith' film which will form the negative mask. This negative will, of course, display the whole picture and it is at this stage that the reflection is isolated from its surroundings. This isolation is accomplished by 'blocking out' the surroundings where necessary with blocking out medium. The object of blocking out is to leave clear film where the reflective image appears and to render the remainder opaque. When this is achieved and is thoroughly dry a positive 'lith' film mask can be exposed.

It will be remembered that the negative mask was registered on the pins; it is equally important for the positive mask to register and for this reason contact printing must be carried out on the register base described below.

The unexposed 'lith' film is pressed emulsion up on to the pins. The negative image which has been blacked out is now registered and laid over the unexposed film. Over both layers a piece of plate glass (just smaller than the distance between pins) is positioned in order to secure good contact between the negative and the film. The film is then exposed using the enlarger as a light source.

As the enlarger still contains the original negative it will be necessary to prolong the exposure in order to expose the 'lith' film beneath the negative mask for sufficient time to produce a solid black image. After processing, the positive mask will show a black silver image in the place of the reflection and clear film elsewhere. This image may need slight retouching to ensure that the reflection area is completely opaque.

It is now possible to multiple-print the whole

A number of prints of a figure were torn into small elements and arranged on an acetate sheet as the first image of a two-colour silk screen print. The collage was photographed on Autoscreen at 5 x 4 in. size and then enlarged so that the screen size was about 30-40 lines per inch. The second colour was made from a photogram of the first collage and during printing from the second negative the image was shaded so as to produce a graduation of tone dot over the whole area. Care was taken to arrange the screen angles in such a way as to avoid a strong moiré pattern, i.e. a secondary overall image built up by the dot patterns interfering with one another —*John McGreggor.*

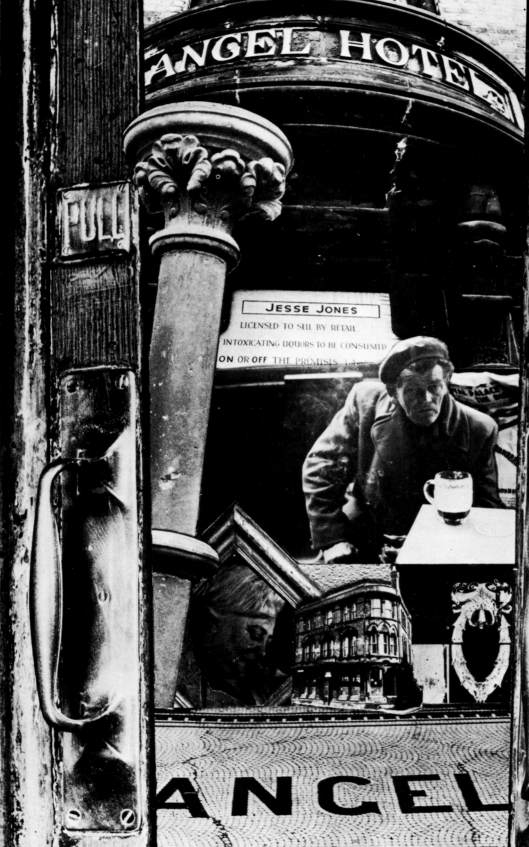

picture, starting with the main image. The positive mask is placed on the register pins and the images of the original negative and the mask should coincide accurately. If for any reason this does not happen the register base will have to be removed from the enlarger baseboard and brought into perfect register. When accurate register has been proved then the positive mask is lifted and replaced with the bromide paper beneath it. The first exposure is made and the paper stored in a light tight place with a marking on the top right hand corner. The positive mask is removed and the negative mask temporarily placed on to the register base. This enables the second flower texture negative to be arranged in conjunction with the negative mask. Once this is done the bromide paper can be put under the negative mask and receive its second exposure. It can then be processed and the multiple printed image is completed.

It is hoped that it will be evident from the example above that this technique may be applied to solve innumerable visual problems and, as is the case with most ideas outlined in this book, one method may easily be combined with another, offering infinite scope for exploration.

Collage

Collage, as most people will already know, is simply mounting assorted flat or textured surfaces/images together on the same two dimensional plane. The activity is a very old one now but it was felt to be worthy of inclusion here in respect of using photographic images, as it is complementary to many of the other areas of investigation suggested in other chapters. Here we are mainly concerned with the visual considerations involved in bringing together one image with another and, although for the sake of clarity and simplicity the discussion will be largely confined to using paper prints on a flat surface. However, whatever is said about opaque prints often applies equally well to

A collage produced for a client in which the atmosphere of an old pub was depicted as a subject for a large photo mural to be hung in the new premises. A straight collage, recopy and enlargement —*Alan Boyson and Jack Tait.*

Pages 108-109

One of the simplest forms of multiple printing — the first image is printed holding back the second image areas slightly and then the second image is printed holding back the first image areas. Care must be taken to ensure that the top right hand corner of the paper is labelled when it is removed for positioning the second image. This image also used in colour coupling —*Jack Tait.*

Straight multiple overprint, no shading —*Jack Tait.*

translucent images on film, translucent paper or stripping film and that the support need not be a flat white surface, but may be any material, tone/colour and presented in slight depth by using layers of film or transparent plastic between the layers of image.

In beginning to experiment with collage it should be remembered that most photographic images are quite detailed, complex and contain a wide range of slightly different tones. Accordingly, the first step may be to examine the visual relationships involved in placing one small image on a larger one. The two factors which have to be considered are the picture contrast of each image and the shape and weight of each, particularly where they join at the edges. The feeling of depth which is created is dependent on the tonal relationship. The shapes of one image in relation to another will govern the composition, balance and content of the pictures and will offer scope for the juxtaposition of dissimilar subjects. In the following paragraphs an attempt has been made to examine some of the many visual ideas which are suitable points of departure for photographic collage.

Collage ideas
One simple yet effective idea is to use two images of differing contrast, i.e.: a contrasty image mounted on a soft background. A version of this idea is to achieve the softening of the background image by interposing a diffuser such as a sheet of Permatrace or tracing paper between the front and rear image one. In addition, the slight mechanical separation enhances the effect.

Colour
Colour may be used in a similar way in order to achieve separation between one image and another. The individual units are toned or colour coupled as described earlier and then cut and mounted.

Reproduction of another photo mural job in which the aircraft elements were photographed, put onto lith film and then multiprinted to create this design. One of a series of four, scale, 10 feet wide —Alan Boyson and Jack Tait.

111

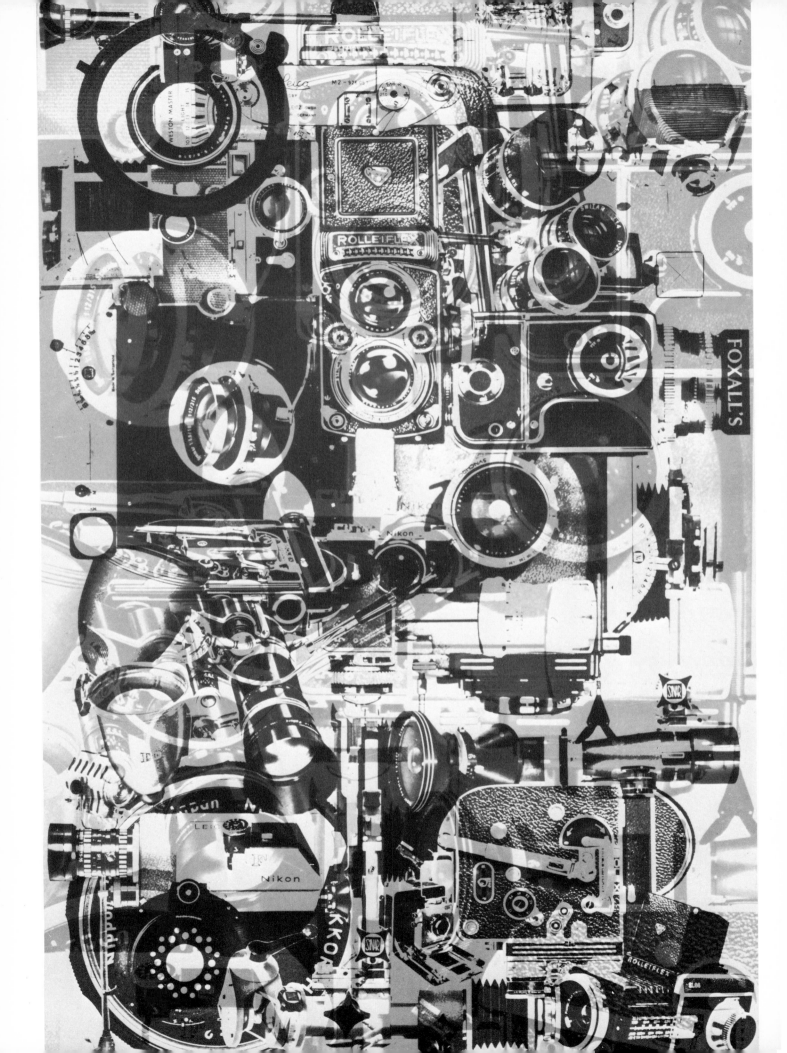

Texture

A third approach to the solution of collage the design problem is to employ areas of texture varying in size, depth of tone and sharpness. Such areas may be cut, or torn and used individually or in groups forming a large textured area built up from many pieces or layers of small parts. It does not necessarily follow that the texture should 'lie flat' on the picture surface as effective use can often be made of textures which have a perspective. The easiest illustration of this idea would be a texture of a rough stone wall receding into the distance with a consequent reduction in the size of the stones. This would create an interesting illusion of depth when put side by side with flat areas.

Up to this point all the images discussed have been described in terms of positive images. There is, of course, no reason why both negative and positive images should not be used together to enrich the visual fabric of the collage. At the end of this chapter an outline is given about making copy negatives. Making a film positive from a negative is a similar procedure and when completed may be printed on to bromide paper to produce a 'negative' print. Some care must be taken when using negative images with positive ones in respect of the tonal balance of the two entities. It is all too easy when making negative prints to obtain over-contrasty results which do not blend well with the normal contrast of positives.

Cutting and mounting

The practical aspects of collage are extremely simple in that pictures are either cut or torn. For the most accurate work the pictures should be cut with a razor blade or retouching scalpel and the cut itself should be at an angle so as to undercut the paper base and leave the emulsion overhanging. This method ensures that joins are less noticeable when mounting is carried out.

There are numerous methods available for

One of a series of exhibition board advertisements designed for a camera and general photographic wholesale and retail company. The original collage made from clippings was copied on to lith film and then printed twice, once full size and once greatly enlarged, so that the second image 'spilled' over the picture area creating a background texture. Many mural size pictures may tend to lose impact when reduced and are better viewed at the size for which they were designed.

mounting prints on to card but the best of these, 'dry mounting' with shellac tissue, is not suitable for collage. The most suitable dry mountant is the petroleum-based 'Cow gum' and this presents few problems in use. It is permanent enough for most purposes and in any event many collage effects are often copied and reprinted, in order to have more than one example available.

If extremely precise size matching is sought as is essential, for example, in laying down mosaics of air photographs, two additional courses are possible. One is to rectify the picture geometry by optical means during the enlarging stage. This means tilting either the enlarger baseboard or negative carrier or both to expand or diminish one part of the picture in relation to another. The second course to adopt if the exact shape is not easily obtainable by the first is to stretch the fabric of the bromide paper. This technique is carried out when the print is wet using hot water to induce maximum pliability. Following stretching, the prints are mounted wet using a wet paste mountant. The support on which the collage is being prepared must be of stout card and balanced on the back to minimise the curling which occurs when the prints dry. Stretching prints when wet must be done with some care and it will be found that bromide paper stretches more in one direction than the other owing to the direction in which the fibres lie. Most paper is made in a large long roll and it is found that paper stretches further along the direction of the roll than at right angles to it. The maximum stretch which should be attempted is relatively small, being in the order of ⅛ in. to ¼ in. on a 10 in. length of paper.

Quality in copying

As implied above, the results of a collage may be copied and the final picture presented as a complete entity. This is a straightforward activity provided that prints of different colour have not been used and that the result does not rely heavily on the

Harmonograph patterns, because of their linear nature lend themselves to techniques such as multiple printing and it is possible to repeat the image many times without losing the feel of the original — *Nicollette Tait.*

114

115

intrinsic quality of the original material. In copying any original on to film and subsequently reprinting it must be remembered that some loss of quality and an increase in contrast will often result.

To minimise quality loss the copy negative should be made on a large negative size and the processing should be such as to prevent any appreciable gain in contrast. The film to use for the copy negative should be soft working continuous tone stock such as Kodak CF8 or Ilford N5 31 and the exposure must be full to ensure good separation in the shadow areas. The negative should be developed in a diluted M.Q. developer such as Kodak D61A 1:3 for no more than three minutes at 18°C. If a densitometer is available then the density range from the densest part of the negative to the thinnest should be in the region of 0.7 to 0.8. This will ensure that the copy negative will print on Kodak grade 2 or Ilford grade 3 paper. In the absence of measurement the visual appearance of the negative should be slightly flat when compared with a conventional negative.

The above comments on collage and copying may sound to some readers to be a little involved and difficult, but the reason for their inclusion apart from academic interest is that the techniques described have been used many times by the author and a colleague to produce murals, one of the largest measuring 16 ft. x 8 ft. This procedure of making technically excellent copy negatives meant that large enlargements of what were very small originals — often 10 in. x 12 in. was an easy task which resulted in only minimum loss of quality. By applying control of the overall density of the copy negatives it was also possible to arrange for exposures in the enlarger to be as short as two minutes for a 10 ft. print, and the grade of paper used was always the same. This latter point was an important economic consideration where large quantities of paper were involved. Obviously any image can be copied and enlarged and making very large prints is

Negative image double print. Each separate image was enlarged as a positive on stripping film and before they were removed from their base the two were sandwiched together and contact printed. A very soft working developer was used to keep the contrast of the film low, e.g. Kodak D76 diluted 1:1. A brewing vat door combined with an image of concrete pipes —*Jack Tait.*

a fascinating area to explore. There are no insurmountable technical difficulties — producing large prints simply needs large instead of small dishes. One fortunate fact is that large 'mural' paper is made in rolls and following exposure which is best carried out on a horizontal set up, the prints may be rolled through the developer, fixer and wash. This means that trough shaped dishes or sinks slightly larger than the paper width are all that is required and this represents a considerable saving in darkroom space.

Finally a collage idea which is by no means new is worth examining if only because it is quite different to those above. This consists of starting with a conventional print and cutting it into a number of strips, each of equal size. The strips are then moved or rearranged and the elements of the new image mounted. The natural extensions of this idea are to cut the image into a few squares and turn them round, or to cut a perfect circle out of a print and move it through an angle. By a slight modification of the strips or square idea two images may be interwoven using tone, colour or content to achieve the separation and impact.

The ideas suggested here are just a few of the ways in which images may be used in collage form and it is assumed that the reader will think of many more, particularly after attempting some of those outlined here. Furthermore, the headings which have been covered in this section do not by any means represent an exhaustive catalogue of the ways in which the photographic image may be modified. For instance, no mention has been made of the visual and technical facilities inherent in the overworked tone separation and solarisation effects.

Xerography

by Charles Arnold

The word xerography is a compound of two Greek words—xeros, meaning "dry" and graphos meaning "writing".

The Xerox Corporation defines xerography as a clean, fast, dry, direct positive, electrostatic copying process, requiring neither water, liquid chemicals, nor intermediate film negative. A darkroom is unnecessary.

Xerography, as a strange exciting kind of image making, started for me in 1965. I have been involved with photography or the teaching of photography as a form of image, idea exploration since 1949. Before that time I was officially a student (an art student).

The exploration of xerography started for me when accidental images, appealed to me when copying library materials and personal notes (which inevitably contain great numbers of unrelated drawings or "doodles"). These copies led to deliberate selection of images and drawings to be copied on the office Xerox copier.

For years I had been fascinated by and satisfied with the silver image. There were times when I longed for a technical acceleration of the process and an extension of some of its aesthetic limitations. The Polaroid process presented a partial solution of the problem with the immediacy of its image. But the process was expensive and the finished images too restricted in size. Polaroid also maintained one characteristic that I often found bothersome in silver process images, in that a photographic emulsion on paper is in itself monotonously uninspiring stuff. The Xerox image was immediate!

Pages 120-1 and 122-3 Xerox images made in a conventional office copying machine from the original bromide prints opposite — Jack Tait.

119

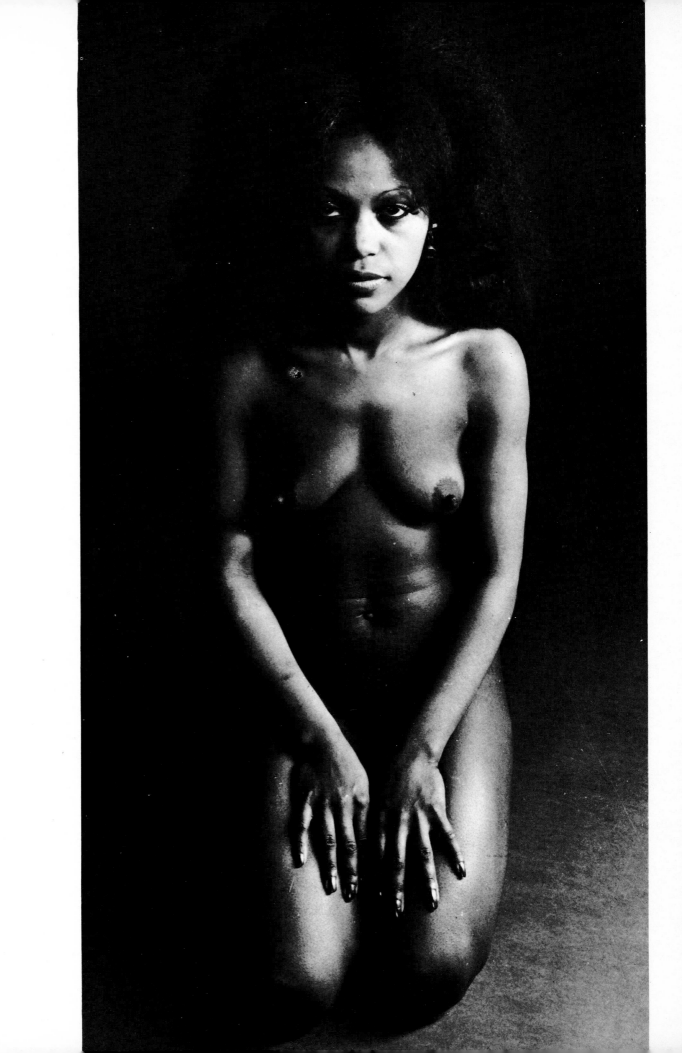

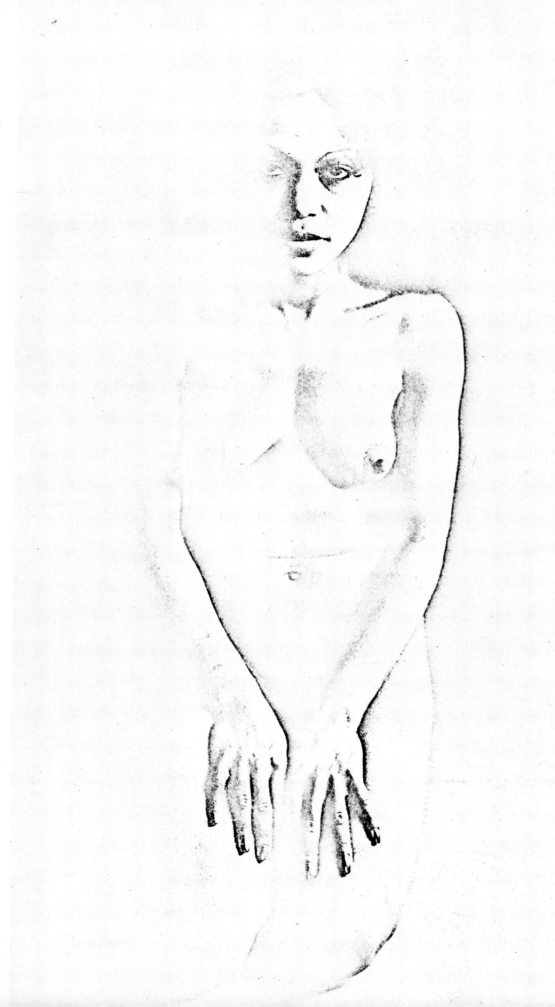

The thing that most interested me was the way the process responded to large areas of black. (Until recently, Xerox copiers would not hold large areas of solid black and a rich ghost edge, very like a 'sabaltier' effect occurred.) I then discovered that one could reproduce images on coloured and textured papers, by simply feeding the proper size and weight of coloured and textured paper to the machine.

This was the beginning of the exploration! I then found that a Xerox model camera existed and was used for making paper xerographic offset plates. By eliminating the copy frame I found that I could make direct xerographs from three-dimensional objects and transfer the image to almost any colour or texture of fine paper. The plate size of the model is 9 x 13½ in. The image is an exact transfer and I find that size quite adequate.

A selenium coated plate is electrostatically sensitized in the model D processor. It can then be exposed in the camera, any camera that the plate will fit. One difficulty of the process is that the plate has a speed of 1 ASA. This has not been a hazard for I have been content to work in the studio with still life material. Long exposures allow one time to reflect on why one makes an image.

This wonderful, complex electrical monster transfers tiny bits of fusable plastic into all kinds of elegant paper by 10,000 volt charges, at my will.

So the reason for using the xerox process evolved and now new possibilities are becoming clear. The early reasons for adopting it were:

1. To make finished images quickly, not for the sake of speed but to allow me to judge a finished work. To make aesthetic judgement and then change structure, tonality or detail to redefine the image. (The whole process, from exposure to finished transfer takes less than six minutes.)
2. To use the camera and conventional lights to electronically produce exquisite quality permanent images without film or wet processing.

Xerox image of rock, made from a bomide print in a conventional machine. By repeat copying and printing these could be developed into more complex prints — Jack Tait.

125

3. Heresy! To eliminate the need for darkroom, darkroom time and materials. I hate darkrooms and the thousands of hours that I have spent in them — hours that could have been spent in making pictures.
4. To be able to explore the possibilites of using surfaces and colours of fine papers as part of my image.
5. To combine image making abilities by working in two media. I can physically alter the transferred xerograph before fusing the plastic to the surface by rubbing, erasing or smudging the toner. After the image is fused I can draw or paint on the xerograph or I can wash, draw or paint on the paper and then transfer the camera image on to the surface.

The xerographs that I have made are direct positive or negative images. The choice between positive and negative is simply a matter of the electronic polarity of the sensitizing charge to the plate.

The images that I make are contrived rather than found. I enjoy being in control of the relationship of objects and people and bringing illusions of reality or fantasy into being.

Technical process:
1. The selenium coated metal plate is sensitized in a Series D processor by inserting a charge shot and pressing the button.
2. The slide is inserted in the holder while still in shot.
3. It is exposed by inserting in the back of the camera, pulling the slide and making exposure, returning the slide. It is then removed from the camera.
4. The holder is placed face down on the toner cascade tray. While holding firmly in contact, the slide is removed and the holder then clamped to the tray.
5. The cascade tray (which contains thousands of tiny glass beads that carry toner across plate) is then rotated on a swivel which allows the toner,

130

carried by the beads, to cascade across the exposed plate. The exposed portions of the plate will have lost their electrostatic charge and will reject toner. Those areas not affected by light will attract and hold toner.

6. The holder is removed from the tray and placed very carefully, image up, in charge shot. Paper for the transfer is gently placed one edge down and the charge button pressed, then the holder and paper are pushed into the unit. With the button still depressed the holder is removed. The toner has now been electrostatically transferred to the paper.

7. The paper is lifted by one corner and gently removed from the plate. The toner image is easily dusted, moved and smudged.

8. This fragile image is fused to the paper by heat or solvent fumes which melt the toner into the fibre of the paper.

In Conclusion

The photographic image is capable of immense development beyond the familiar initial stages. The chief preoccupation in this book has been with describing the fascinating way in which this image may be changed or enhanced by a variety of special techniques and processes. Each process lends its own character to the initial pictures and this combination results in a new visual entity. The inclination and emphasis, hopefully borne out by the nature of the visual material, is on the imaginative application of these processes and on the development of fresh visual ideas. The illustrations have given much pleasure in their production to those responsible — mainly students and staff in the school of photography at the Manchester Polytechnic, England.

The benefit to students of being involved with such print processes is that they represent a secondary stage in their visual development, the first being rightly concerned with the production of the imaginative photographic image. This secondary stage is concerned with putting the photograph to use as opposed to a close pre-occupation with the picture itself. This calls for a different type of visual thinking. Practical applications of the photographic image lead directly to such related fields as audio visual programmes with tape and slide, television and film. This type of approach and activity is essential to the education of people intending to make their career in visual communications. It has been found repeatedly that the benefits mentioned above have been very real and tangible; the work ultimately submitted for the students diploma displays a breadth of visual awareness which, in part,

may be attributed to working with photographic images with what might be termed a 'fine print' attitude. It is not important which method or technique is used — indeed the processes outlined do not and could not represent an exhaustive list. Nor need they be the exclusive property of these involved professionally. Indeed, there is much to be gained by people not themselves involved in the practical aspects. Many whose work requires, or where ideas could spring from, a photographic origin should derive much benefit from a close look into what can be done in this area.

Making images like these in this book is an enjoyable and stimulating activity not least because of its exploratory nature; the author has greatly enjoyed creating his own pictures and seeing the results of others similarly inclined. It is hoped that readers will, at least, derive some pleasure from these images and, at most, benefit from personal involvement in making their own.

Appendix I

Litho and screen images

The primary requirement for most graphic processes is that the original image, either a drawing or photograph, has to be converted into a state which the process can use and accept. Originals are usually continuous tone and often in colour and these characteristics must be broken down into simpler components.

In Appendix II the subject of colour and colour separation is dealt with briefly. Here we are concerned with the production of the intermediate step between a continuous tone image and the printed image.

The requirement is for an image which is either wholly black or extremely dense and clear parts which are of extremely low density. There are two ways of converting a continuous tone image into a suitable state for printing and two materials with which to achieve it. One material is termed a lithographic or 'lith' film and simply turns black or remains clear according to the amount of exposure it receives. The other has within it's structure a half-tone dot which is able to convert a continuous tone image into a form which is still all black or clear film but which creates the illusion of a continuous tone image when printed. This is best understood by referring to the enlarged portion of a half-tone image in the diagram. This material is a proprietary brand of Kodak and is called Autoscreen.

For the sake of initial simplicity the technique about to be outlined assumes that both materials will be used as projection material in the production of film positives. (Autoscreen was designed to

work best as a negative material and for optimum results should be used this way by adopting the additional step of making intermediate continuous tone duplicate positives and negatives. However it does work in the simpler way described and in many cases the results are acceptable.)

The procedure is that the original negative is placed in the enlarger and the image enlarged to the final size. Instead of using bromide paper as would be normal, a film used is either 'lith' or autoscreen depending on the image requirements. This film must be handled only by a red safelight e.g. a Kodak 1A at 6 ft. with a 25 watt bulb. The exposure latitude for these films is extremely narrow and a test strip must be exposed with stops close together for example 4, 6, 8, 12, 16, 24, 32 sec. The developer required is a special type which is mixed and kept in two separate bottles and labelled Part A and Part B. Before use, the developer is mixed from equal parts of A and B and must be at 68°F/18°C to work properly. The development time of 3 min. is also important, for optimum results for the first 30 sec. of development continuous agitation should be given and for the last minute none. The resulting image should be very black and for optimum detail from the negative only the exposure should be carefully adjusted. In both cases, that is, with 'lith' film and autoscreen, the techniques of holding back and printing up various parts of the image should be used. With autoscreen the size of the dot can be controlled within small limits and this is apparent in the areas which have not received any exposure in the enlarger. The dot size is increased by 'fogging' the autoscreen to an OB yellow safelight at a

distance of 2-3 ft. for approximately 10-40 sec., depending on the result desired.

Following development, the film positives are fixed, washed and dried in the normal way. After washing, the positives may exhibit a slight brown stain in places. This is unwanted as it is detrimental in the next stage and is easily removed by a short immersion in a weak solution of potassium ferry-cyanide and plain hypo. It is inevitable that some retouching will be necessary and this is done with an opaque medium on the non-emulsion side. No effort should be spared to make the positives as perfect as possible as some detail is invariably lost and at the film positive stage virtually nothing can be done to rectify any lack of detail in highlight and shadows. If faults are apparent in the 'liths' for example, pin holes or brown instead of black images, these are due to insufficient development and exhausted developer respectively. A and B developer, once mixed, does not last more than a few hours (two to three) and should be used fresh, whenever possible.

Once some skill has been acquired at making film positives they can be kept and used in many alternative processes. The stripping film mentioned in this book may also be processed as a 'lith' film in A and B and lends itself to uses where a very flexible image is needed to follow the contours of a three dimensional surface.

Lastly there are two major types of 'lith' material available on a film base. These are:
1. 'Lith' film proper which is dimensionally stable and capable of retaining extreme detail.
2. Translucent paper, which is much cheaper and,

as its name implies is on a base-like paper, but it is translucent. This is quite suitable for such work and is a very tough material. The trade names for all these Kodak products are (a) Kodalith Ortho type 3 (b) Kodalith Translucent paper and (c) Kodak Stripping Film.

Appendix II

Colour theory

To supplement understanding of colour separation and printing it may be helpful to cover the basic theory of colour.

In the three colour theory it is held that almost all colours in nature, visible to the eye, can be synthesised by mixtures of the three primary colours, red, green and blue. This principle can be demonstrated by triple projection in which three projectors are fitted with red, green and blue filters and their images overlapped. By altering the proportions of each colour, that is, by reducing the light from one or more projectors, almost any colour can be produced. The dramatic fact that yellow is a mixture or red and green light can be demonstrated in this way.

This principle is directly applicable to many light machines which employ three light sources and some method of mixing the colours.

This is known as the additive principle because colours are produced by adding coloured lights together to make other colours.

The idea of colour separation is also based on this principle — that an original can be split into red, green and blue components so that it can be reproduced. The act of printing the separation depends on the subtractive principle, which follows below. The reason why the additive principle can not be easily employed in reproduction is that if red and green are overprinted, a yellow is not produced, as there are not two sources of light but two dyes. It is necessary to have colours which, when superimposed, will generate athird colour. These colours are called secondary colours and the subtractive

principle relies on their use. These colours are yellow, magenta (blue/red) and cyan (blue/green) and are the complementary opposites to the primary colours (see diagram). By adopting the secondary colours an original may be reproduced and the colour formed in the following way:

Yellow and magenta will produce red because yellow is 'minus' blue and magenta is 'minus' green. This only leaves red. Another way of explaining this is that yellow equals green and red, and magenta equals blue and red, the blue and green cancel each other out and leave red. Similarly, magenta plus cyan produces blue, and yellow plus cyan produces green.

All these theories can be demonstrated by the reader for himself if six filters are chosen from a strand gelatine sample book. By putting a red and green filter together it will be seen that they pass very little light but by putting a yellow and cyan filter together a good green will result. The choice of filters is quite critical as no filter is perfect. Theoretically, a blue and red filter should pass no light when added together but owing to dye deficiencies they do. In light terms a good blue filter may look more violet than one would expect as, at school, cyan is wrongly referred to as blue and magenta as red. When using paint, pigment or dye, cyan (wrongly termed blue) is seen to mix with yellow to make green. The test of a blue filter is that it should not make a good green when added to a yellow filter.

Colour separation

In some of the processes outlined in this book it is

possible that images might be needed which are in the form of colour transparencies, or the reader might wish to produce three or more 'plates' from a transparency in order to print in full colour with slight modifications. In either case it might be helpful if the techniques of making separation monochrome negatives representing each primary colour was described.

A colour transparency can be reproduced in a graphic process if three of the images made from the primary colours red, green and blue are printed in the secondary colours cyan, magenta and yellow. The steps in a simple but practical modified procedure are listed below with the reasons for each action added. It is only necessary to know the path of one primary and one secondary colour as the others behave in the same way.

1. The transparency is placed in an enlarger and the image enlarged to size. This will depend on the monochrome film in use, but it is normal to use 5 in, × 4 in. material.

2. Three special separation filters are required, in red, green and blue — the set is matched so that they divide up the colour in the original in the correct way. The Wratten numbers for a set are No. 25, 58 and 47B and these are obtainable from Kodak. The blue filter which passes mainly blue light is placed over the enlarger lens before exposure and the first piece of monochrome film is exposed. This film must be a medium speed panchromatic (that is sensitive to all colours) film and the darkroom is normally used in total darkness. A test strip indicates the correct exposure and in the case of the blue filter film it is advisable to raise the normal development

time by 20-30% to increase the contrast. The red and green exposures are given normal development.

3. The object in controlling the exposure and development is to achieve three monochrome negatives (corresponding to the red, green and blue in the transparency) which match in density and contrast. The negative made through the blue filter will be dense in those areas where blue occurred in the transparency and thin or clear where there was green or red.

4. This blue record as it is termed is then enlarged to the size of the final print and the material used will be either Autoscreen or 'lith' film. (In conventional colour separation in the printing industry the half-tone screen is put on to the separation negatives in a special process camera and these negatives would be made full size. However, the method being described has been modified to enable the photographer with simple equipment to use the technique.)

5. The positive produced from the separation negative is now dense in the places corresponding to the transparency which were red and green and clear in the places where blue was present. It is now therefore a negative record of the blue in the transparency.

6. As this positive is a negative record of blue it can be printed in the opposite colour to blue which is the secondary colour yellow. Yellow is sometimes called 'minus blue' in printing.

7. If this procedure is carried out for each colour then the final result in terms of yellow, magenta and cyan is a reproduction of the original transparency.

The procedure of making separation negatives is less important than its potential as a further method of changing the photographic image. It follows from the above that any colour in an original transparency or for that matter colour negative can be separated out from the background by a careful choice of filter. The results of these separations can then be combined in a variety of imaginative ways using all the ideas suggested in this book or many more which will occur to the reader.

142

Formulae: Sulphide Toning

Stock bleaching solution

Potassium bromide	50 gm
Potassium ferricyanide	100 gm
Water, to make	1000 ml

For use: take 1 part of the above to 9 parts water.

Stock sulphide solution

Sodium sulphide, pure	200 gm
Water, to make	1000 ml

For use, take 3 parts of stock sulphide solution to 20 parts of water.

Solutions required.

Colour developer

(i)	Genochrome	11 gm
	Water to	100 ml
(ii)	Calgon	2 gm
	Sodium carbonate anhyd	17 gm
	Sodium formaldehyde sulphoxylate	5gm
	Potassium bromide	1 gm
	Water to	1000 ml

Coupler solutions

Magenta	p-nitrobenzyl cyanide	0.5 gm
	Alcohol	100.0 ml
Yellow	Acetoacet-2 : 5-dichloranilide	2.0 gm
	Alcohol	100.0 ml
Blue-green	2 : 4-dichloro-1-naphthol	1.0 gm
	Alcohol	100.0 ml
Blue	1-Naphthol	1.0 gm
	Alcohol	100.0 ml

The stock solutions keep well in brown bottle. The working solution should be mixed before use as it is unstable, and it is prepared by mixing three parts of developer (i) with 100 parts of developer (ii) and then adding ten parts of coupler solution. Mixtures of coupler for a complete colour range are:

Crimson
 Magenta 8
 Yellow 2
Scarlet
 Magenta 5
 Yellow 5
Orange
 Magenta 2
 Yellow 8
Yellow —
 Stock solution
Green
 Yellow 5
 Blue-green 5
Blue-green —
 Stock solution
Blue —
 Stock solution or
 Blue-green 8
 Magenta 2
Violet
 Blue-green 5
 Magenta 5
Purple
 Blue-green 2
 Magenta 8

Note: It is advisable to use a plain hypo fixer throughout.